DATE D

…for is there anything…,

anything more charming,

more productive,

more positively exciting,

than the commonplace?

Charles Baudelaire

Walker Evans Simple Secrets

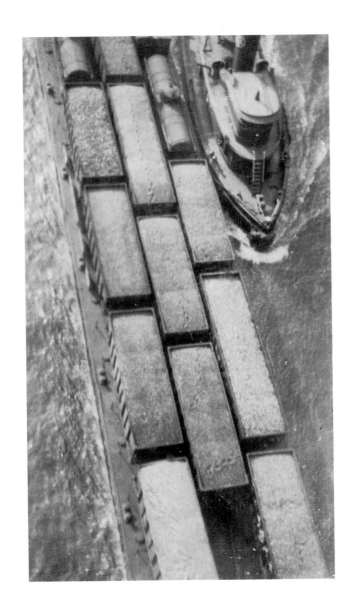

Walker Evans Simple Secrets

Photographs from the

Collection of

Marian and Benjamin A. Hill

Ellen Fleurov, Curator of Photography

High Museum of Art, Atlanta / Distributed by Harry N. Abrams, Inc., Publishers

This publication accompanies an exhibition organized by the High Museum of Art and curated by Ellen Fleurov. Generous support for the exhibition was provided by Marian and Benjamin A. Hill. Publication of the exhibition catalogue has been supported by Christie's in celebration of the 20th anniversary of its Photographs Department.

Library of Congress
Catalog Card Number 97-77582
ISBN 0-939802-85-6 (clothbound)
ISBN 0-939802-86-4 (paperbound)
ISBN 0-8109-6362-0 (Abrams)

All photographs except nos. 47-52, 54-57, 59, and 61 © Walker Evans Archive, The Metropolitan Museum of Art, New York.

Cover: *Self-Portrait, Juan Les Pins, France*, 1927
Frontispiece: *East River, New York*, 1929
Back cover: Leslie Katz and Walker Evans, "Interview with Walker Evans," *Art in America* (April 1971), 87.

Edited by
Kelly Morris and Anna Bloomfield
Printed and bound in China

Distributed by
Harry N. Abrams, Incorporated, New York

Exhibition Tour

High Museum of Art
Atlanta, Georgia
March 24–June 14, 1998

International Center of Photography
New York, New York
September 18–November 29, 1998

Whitney Museum of American Art at Champion
Stamford, Connecticut
December 11, 1998–February 24, 1999

The Detroit Institute of Arts
Detroit, Michigan
April 14–June 27, 1999

779
EV16w

To Thomas Morgan Hill, 1909-1991

Acknowledgments

For over three years, I have had the distinct pleasure to work with Marian and Ben Hill in bringing a portion of their remarkable collection of Walker Evans photographs to the public. That an exhibition of this scope and quality could be drawn from a single collection is indeed a tribute to their keen discernment, knowledge, and passion as collectors. I am indebted to Marian and Ben, and to their children, Audrey and Edward, for their unfailing support and graciousness in allowing us to present this fine collection in Atlanta and the other cities to which it will tour over the next year. It is our hope that audiences will share our sense of the power of Walker Evans's photographs, and that they will, to use the words of the poet William Carlos Williams, "see what we have not heretofore realized, ourselves made worthy in our anonymity."

Exhibitions of this size depend upon the contributions of many benefactors, and I would especially like to thank Christie's for their generous support of this publication and to recognize the kind assistance of Rick Wester, Vice-President and Director of Photographs; Catherine Vare, Director of Museum Services; and Alison Thompson, Regional Representative. We are also very pleased that this exhibition will travel to other museums, and I would like to thank our colleagues at the International Center of Photography, New York, Willis Hartshorn, Director, and Ellen Handy, Associate Curator; The Detroit Institute of Arts, Maurice D. Parrish, Interim Director, and Ellen Sharp, Curator of Graphic Arts; and the Whitney Museum of American Art at Champion, David Ross, Director, Whitney Museum of American Art, New York, and Cynthia Roznoy, Branch Manager.

I would like to acknowledge the encouragement and guidance of the many curators, photographers, gallerists, and others who have so ably assisted Ben Hill and me over the years. First, our thanks are due to Judith Keller, Associate Curator of Photographs at The J. Paul Getty Museum, whose impeccable scholarship on Evans has been extremely important to the field and to this project. She has graciously answered many technical questions pertaining to the Hill collection, and her expert assistance is greatly appreciated. We have also benefitted from

the valuable insights and counsel of Jeff L. Rosenheim, Assistant Curator, Department of Photographs at The Metropolitan Museum of Art, and I thank him, as well, for permission from the Walker Evans Archive to reproduce most of the works in this catalogue. I would also like to acknowledge the following individuals who so generously and promptly responded to our requests for information: Harry H. Lunn, Jr., Lunn Ltd., New York and Paris; Carol Ehlers and Shashi Caudill, Ehlers Caudill Gallery Ltd., Chicago; Gilles Mora; Ed Grazda; Rodger Kingston; and Jerry Thompson.

I extend my thanks to Ned Rifkin, Nancy and Holcombe T. Green, Jr. Director of the High Museum of Art, and to the entire staff of the Museum, with whom I am privileged to work. I would like to particularly acknowledge the following people for their contributions to this project: Michael E. Shapiro, Deputy Director and Chief Curator; Anne Morgan, Director of External Affairs; Rhonda Matheison, Director for Business Affairs; Marjorie Harvey, Manager of Exhibitions and Design; Jim Waters, Chief Preparator; Jody Cohen, Associate Registrar; Larry Miller, Works on Paper Technician; Nick Clark, Eleanor M. Storza Chair of Education and his staff, particularly curators Joy Patty and Kathleen Peckham Allen; Susan Brown, Manager of Corporate Support; Holly Caswell, Manager of Individual Support; Marcia Mejia, Retail Operations Manager; Roanne Katcher, Manager of Membership; Sally Corbett, Public Relations Coordinator; and Marie Landis, Manager of Special Events. My thanks, as well, to my assistant, Laurie Hicks, for her capable work on all aspects of the exhibition and publication.

Finally, I wish to recognize the talents of those who have been critical in preparing this book–particularly Kelly Morris, Manager of Publications, and Anna Bloomfield, Associate Editor. I am also deeply grateful to John T. Hill, whose visual acuity and intense dedication have guided this publication from the outset.

Ellen Fleurov
Curator of Photography

Preface

Photography is very much like poetry in several ways. Each involves using a medium that is universally available and is frequently used by non-artists for non-art purposes. Words, like photographs, are plentiful and cost little to create. Everyone uses words to communicate to others; virtually anybody can take a camera and make a photograph. To elevate each of these methods of expression to the level of art is considerably more complex than is often understood. It is the heart and mind of an artist that is required to transform the word or image into something of lasting impact and value.

Certainly, the collected works of Walker Evans substantiate that the unsensational and unpretentious can yield photographic images as compelling and poignant as the most eloquent and inspiring poetry. In the hands of Evans, the camera and the photographic print are elevated to a range of emotional and intellectual depths. The directness and beguiling beauty of Evans's vision is startling in its rigor as well as its resonance.

The Marian and Benjamin A. Hill Collection of Walker Evans images represents a critical mass of profound work by one of the greatest American visual artists of this century. Evans's world view, as distilled and extruded through his lens and fixed as image on paper, is both powerful and beautiful. The High is supremely grateful to the Hill family for agreeing to lend these precious prints and for their generous support of this exhibition. Through its presentation and accompanying publication, we intend to honor both the artist and his patrons. This dynamic between the one and the other is what engenders exceptional and excellent collections, and the Hills model this for all of us. Atlanta is fortunate to have such passionate and sensitive collectors.

We are grateful for a generous grant from Christie's to support the exhibition catalogue. This gift was made in celebration of the 20th anniversary of Christie's Photographs Department. I also wish to recognize the important work that Ellen Fleurov, the Museum's Curator of Photography, has done in working with the Hills to bring this collection into the form of an exquisite exhibition and catalogue.

As we view and absorb these marvelous works, let us remember that for Walker Evans, as with any great artist, seeing the world was not merely an existence, but a purpose. It was the medium of photography that enabled this talented and dedicated individual artist to create his remarkable visual poetry.

Ned Rifkin
Nancy and Holcombe T. Green, Jr. Director
High Museum of Art

Walker Evans Simple Secrets

The earliest work by Walker Evans in this exceptional collection assembled by Marian and Ben Hill is a rare self-portrait (checklist no. 2), one of the few photographs the artist is known to have made while living in Europe from April 1926 to May 1927. Evans, then just twenty-three years old, had aspirations of becoming a writer and only occasionally took photographs during his travels in France and Italy. Yet despite his youthful inexperience, Evans produced a work that is poised and knowing and without the hesitancy found in his other surviving photographs from this period. With its elegant reductivism and expressive use of light and shadow, the self-portrait is clearly an early attempt to apply some of the experimental ideas and formal tactics then current in modernist art circles in Europe. But this photograph is fascinating not only for what it discloses about the young artist's formative influences but also for how it prefigures, if only obliquely, the style and character of his mature work.

The writer Andrei Codrescu has commented upon the "paradoxical quality of self-reflection and anonymity which haunts so much of his [Evans's] work," and this fusion of aesthetic calculation and emotional reticence is apparent in the self-portrait.[1] Later in his career, Evans spoke of his desire to "stay out" of his photographs, to eliminate his vestigial presence.[2] This he has done quite literally here, by refusing to be seen except as a shadow, a luminous emanation silhouetted against a blank wall. The self-portrait evokes with an almost uncanny exactness the dictum of Gustave Flaubert, one of Evans's most important literary inspirations, who said, "An artist must be in his work like God in Creation, invisible and all-powerful; he should be everywhere felt and nowhere seen."[3] Traditional expectations of self-revelation are intentionally held in abeyance; rather, the photographer has perceived the camera as an instrument of "self-effacement," a phrase Lincoln Kirstein used to describe the deceptively artless style of Evans's photographs of Victorian architecture when they were first exhibited at the Museum of Modern

[1]
Andrei Codrescu, *Reading Walker Evans' America* (1995), 7. Unpublished essay shared by Codrescu with the author.

[2]
Lincoln Caplan, ed., "Walker Evans on Himself," *The New Republic* 175 (November 13, 1976), 25.

[3]
Quoted in John Szarkowski, introduction to *Walker Evans,* by Walker Evans (New York: Museum of Modern Art, 1971), 11.

Art in 1933 (checklist nos. 21, 24-27).[4] Many of these prints, like the *Jigsaw House, Ocean City, New Jersey,* 1931, were among the first made from large, view camera negatives. They demonstrate just how quickly Evans had assimilated his earlier influences and had begun to codify a new visual idiom–this synthesis of objective report and subjective feeling–with which he would quicken and elucidate our perception of a changing American society and its material culture.

Ben and Marian Hill began to collect photography in 1972, and their collection is stunning in its breadth, from Timothy O'Sullivan's 1873 photograph of *Inscription Rock, New Mexico,* to their most recent purchase of one of Hiroshi Sugimoto's 1990 seascapes. It is, however, the one hundred thirty-two photographs by Walker Evans, of which eighty-eight are reproduced here, which form the nucleus of their holdings and inform in many ways the direction of their other collecting interests. When the Hills first started collecting, photography was only beginning to find popular acceptance in museums and commercial galleries, and their early interest in Evans was prescient if unfashionable, especially within Atlanta's conservative art circles. As John Szarkowski has pointed out: "Walker Evans was less collectible than André Kertész. A Kertész *clochard,* sleeping on the *quai* on the Seine, is a traditional artistic subject, as abstract as a Roman cherub; but Evans's unfortunates have not yet learned to lose themselves in their role; they are still individuals, and might even be mistaken, on the wall of the study, for someone we know."[5]

As the Hills also recognized, Evans's photographs do not readily yield up their secrets, but it was precisely the qualities that make him so difficult to apprehend at first–his lack of sentimentality and artifice, his taste for the discarded and "aesthetically-rejected subject," his subtle yet tireless experimentation–which drew their attention and continue to hold them in thrall, even after twenty-five years of living with his work. The Hills' first acquisition was a portrait of Allie Mae Burroughs, 1936, not reproduced here, which was a gift to them from John Hill, Ben's older brother. John, a member of the faculty of Yale University's School of Art and Architecture, first

4
Quoted in Judith Keller,
Walker Evans: The Getty Museum Collection (Malibu:
J. Paul Getty Museum, 1995), 11.

5
John Szarkowski,
Photography Until Now (New York: Museum of Modern Art, 1989), 276.

6
Quotation cited from author's interview with Ben Hill, August 20, 1997. Tapes and transcript in High Museum of Art files.

7
For an excellent discussion of Evans's subway photographs, see Sarah Greenough, *Walker Evans: Subways and Streets* (Washington, D.C.: National Gallery of Art, 1991).

8
Three of the best-known examples of Evans's montage are a portrait of Berenice Abbott, ca. 1930, in the collection of The Art Institute of Chicago, reproduced in Matthew Teitelbaum, ed., *Montage and Modern Life, 1919-1972* (Cambridge, Mass.: MIT Press, 1992), 10, and *Times Square [Broadway Composition]*, 1930, and a variant of it found in the Getty Collection and reproduced in Keller, *Walker Evans*, 25. I am grateful to John Hill for information on this aspect of Evans's work.

met Evans in 1961 while he was still employed as a staff photographer and associate editor at *Fortune* magazine. Upon Evans's appointment as Professor of Photography and Graphic Design at Yale in 1965, they established an even closer friendship that lasted until the artist's death in 1975. Ben and Marian were first introduced to Evans through John in 1972, and he lived with the Hill family during a stay in Atlanta in July 1973, when he purchased his first Polaroid SX-70 camera. Ben still recalls "sitting around a table at the Old Heidelberg Restaurant in New Haven with my brother and Norman Ives and going through a cigar box filled with subway portraits" that Evans wanted to sell.[6] Two of these memorable photographs (checklist nos. 66 and 68) became the first works of Evans's purchased by the Hills, and they represented an auspicious beginning, for in 1972, the subway portraits occupied a much less celebrated position in Evans's oeuvre than they do now.[7]

The Hill Collection is widely regarded as one of the best private collections of Walker Evans photographs in the United States. Spanning five decades, from the architectural views and scenes of city life of the late 1920s to the purely abstract graffiti of the 1970s, the collection reveals the full complexity and greatness of Evans's achievements. The collection is notable not only for its chronological reach, which allows us to observe Evans's remarkable continuity of vision and insistent exploration of specific themes, and for the superb quality of individual prints, but also for its representation of variant versions of certain pictures, such as the reworking of the *Penny Picture Display, Savannah, Georgia*, 1936, into a postcard format (checklist nos. 51 and 52). Equally significant, the Hill Collection contains thirteen hitherto unpublished works, some of which, like *Brooklyn Bridge Composition*, 1929, shed interesting new light on Evans's prodigious development and working methods.

In 1930, Hart Crane, a friend and neighbor of Evans's in Brooklyn Heights (checklist no. 13), first published his epic poem *The Bridge* in a deluxe French edition illustrated with three gravure plates by Evans. One of these photographs, a view from the bridge to the river and barges below, is found in the Hill Collection (checklist no. 1). Another Evans photograph served

9

Christopher Phillips,
introduction to *Montage and
Modern Life,* 31.

10

Quoted in Maria F. Bennett,
*Unfractured Idiom: Hart
Crane & Modernism* (New
York: Peter Lang Publishing,
1987), 196.

11

All quotations from *The
Bridge* are taken from Marc
Simon, ed., *The Poems of Hart
Crane* (New York: Liveright
Publishing, 1986).

12

Quoted in *Looking Back, Art
in Savannah, 1900–1960*
(Savannah: Telfair Museum
of Art, 1996), 45.

13

The only other known print
of this work is a slightly dif-
ferent version found in the
collection of the Library of
Congress and reproduced in
*Walker Evans: Photographs
for the Farm Security
Administration, 1935–1938*
(New York: Da Capo Press,
1973), plate 397.

as the frontispiece to one of the first American trade editions, also published in 1930, and a vari-
ant of this negative became the basis for the unusual composite image found in the Hill
Collection (checklist no. 11). Photomontage, with its disruption of normative space and the nat-
uralistic appearance of things, was not a technique that Evans used very often and probably not
after 1930. In fact, this work is one of only five such montages thought to have been created by
Evans in his career.[8] Yet Evans's experimentation with this form is not entirely surprising, for,
as Christopher Phillips has written, "montage serves as a sign of an old world shattered and a
new world self-consciously in construction."[9] For both the poet and the photographer, the
Brooklyn Bridge was an emblem of modernity and a marvelous technical achievement, but it
was also, as Hart Crane explained in a letter to a friend, a "symbol of consciousness spanning
time and space."[10] In the "Cape Hatteras" section of the poem, the rising and falling movement
of the bridge's cables is evoked by circular imagery, which also serves as a metaphor for the
artist's own arc of discovery–the ascent of the Wright brothers in their "twinship" approaching
"the new verities" of ether in "oilrinsed circles of blind ecstasy;" their "whirling armatures"
transformed into a warplane that plummets downward "giddily spiralled/gauntlets upturned,
unlooping."[11] Crane's brilliant, packed imagery of flight and descent, gyring perspective and
infinite space, finds a visual correlative in the labyrinthine, Luna Park-like sweep of the bridge
and its inverted form seen in the montage. It is difficult to say whether Evans's intentions here
were consciously symbolic, but he would later repudiate the "romanticism" of such efforts in
favor of "deliberately wrought poetry in the guise of plain, simple fact."[12]

It was in the South during the thirties that Evans made many of his finest photographs, and
those he produced in Alabama in the summer of 1936 are regarded as the best work of his
career. Among these photographs in the Hill Collection is a masterful but less-familiar image of
a rural church found in the town of Sprott, in Perry County, Alabama, just east of where Evans
made his famous portraits of tenant farmers included in the book *Let Us Now Praise Famous
Men,* 1941, produced in collaboration with James Agee (checklist no. 47).[13] Through the frontal

and slight axial placement of the camera, Evans has given this unassuming building a monumentality and heroic presence that were not necessarily found in reality. Twenty-five years after making this picture, Evans would still perceive the power and dignity of such anonymous yet venerable churches when he wrote, "Out-of-the-way churches . . . comprise the most unnoticeable ecclesiastical architecture in the United States. But they are unnoticeable with a vengeance: even the unbeliever must feel their force."[14]

Without knowing of Evans's earlier photograph, the sculptor and photographer William Christenberry, an Alabama native, photographed Sprott Church with a Brownie camera in 1971.[15] Twelve years later, he made another photograph which showed the church without its majestic twin steeples, which had been removed when the porch entrance was rebuilt. Such changes in the name of progress are perhaps inevitable, and we may experience a certain regret at the sheer fact of the loss of buildings like Sprott Church, which epitomized the vitality of the indigenous craft traditions that Evans so greatly admired. Yet we can still take much pleasure in the recognition that what has been altered or no longer exists is restored to us, fixed in the stasis of these eloquent and timeless images.

In looking at the wealth of iconic and unfamiliar works so assiduously and intelligently assembled by Marian and Ben Hill, we are reminded of just how Evans's pictures "have enlarged our sense of the usable visual tradition," as John Szarkowski observed, "and have affected the way we now see not only photographs, but billboards, junkyards, postcards, gas stations, colloquial architecture, Main Streets, and walls of rooms."[16] To endow the ordinary with poetry, "to find in the objects around us the fragrant tenderness that only posterity will discern and appreciate," as the novelist Vladimir Nabokov once wrote, is but one of many gifts which Evans's art has given to us and which can be fully savored in this outstanding collection.[17]

Ellen Fleurov
Curator of Photography

14
Walker Evans, "Primitive Churches," *Architectural Forum* 115 (December 1961), 103.

15
For further information on the relationship between Evans and Christenberry, see Thomas W. Southall, *Of Time & Place: Walker Evans and William Christenberry* (San Francisco: The Friends of Photography, 1990).

16
Szarkowski, introduction to *Walker Evans,* 17.

17
Quoted in Alfred Appel, Jr., *Signs of Life* (New York: Alfred A. Knopf, 1983), 141.

Photographs

Self-Portrait, Juan Les Pins, France, 1927

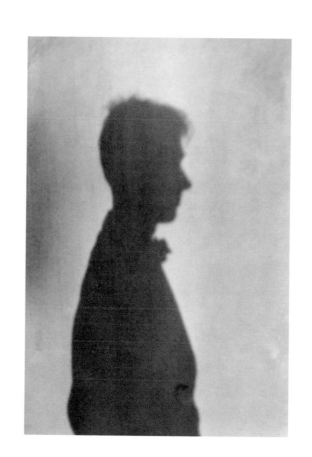

Building with Metal Gate, probably Brooklyn, 1929

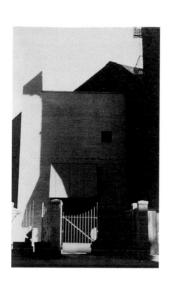

Wall Street Windows, 1929

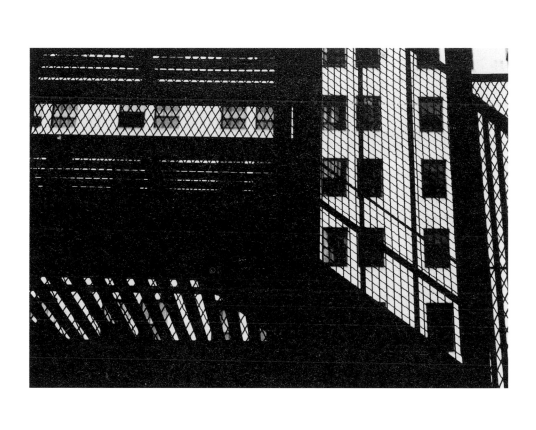

Cranes and Windows, New York, ca. 1928–29

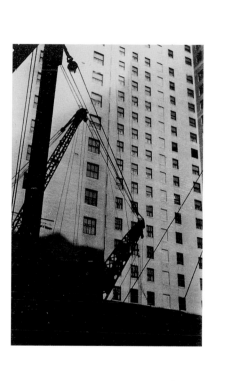

Delancey Street, New York, 1929

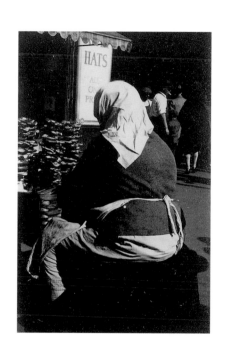

Forty-Second Street, New York, 1929

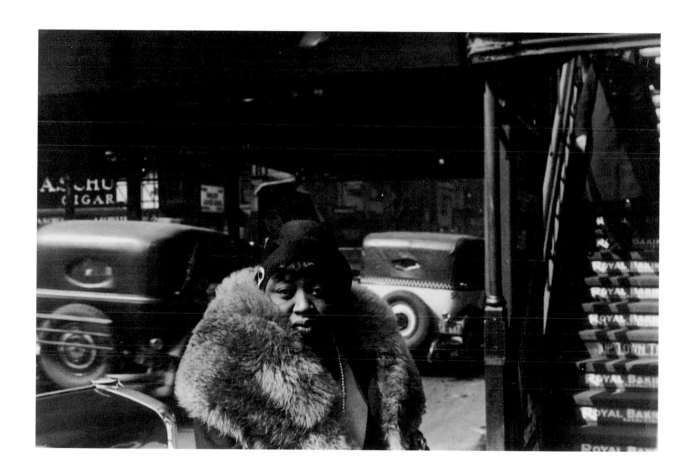

Mannequin, New York, ca.1929

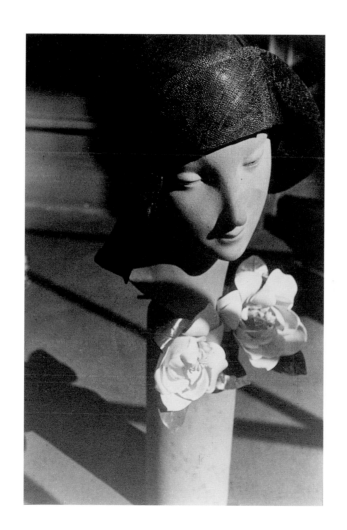

Brooklyn Bridge Composition, 1929

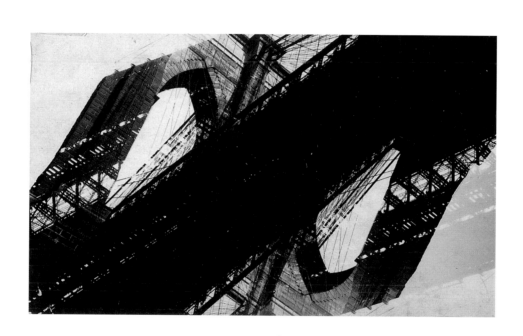

Hart Crane, Brooklyn, New York, 1929

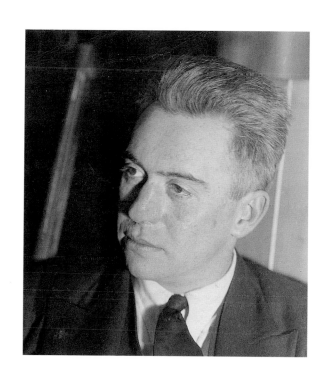

Berenice Abbott, 1930

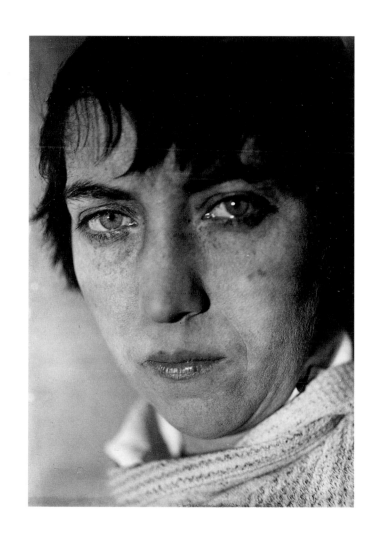

Wash Day, New York, ca. 1930

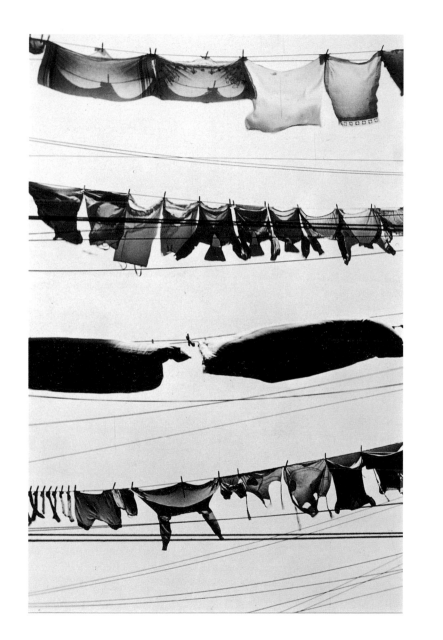

Secondhand Shop Window, 1930

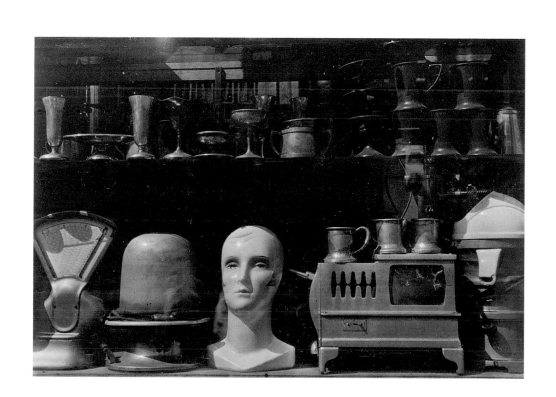

View of Ossining, New York, 1930

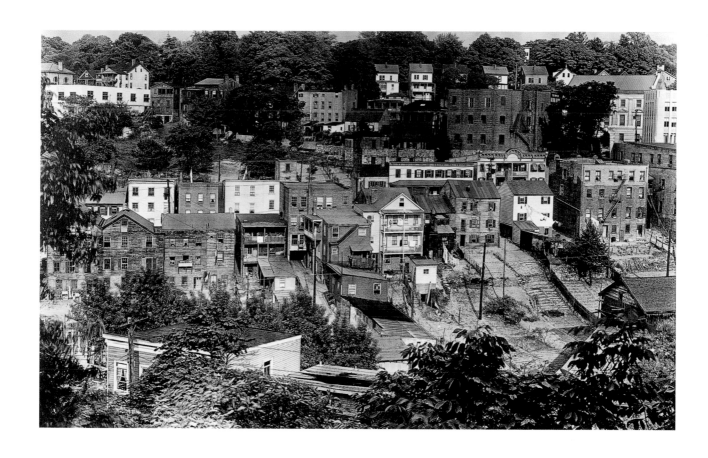

Circus Signboard, ca. 1930

Main Street, Saratoga Springs, New York, 1931

Jigsaw House, Ocean City, New Jersey, 1931

Roxbury Water Tower, Massachusetts, 1931

Moving Truck and Bureau Mirror, ca. 1931

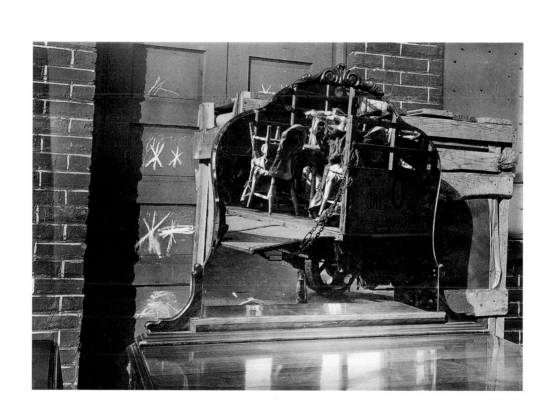

Child in Backyard, 1932

South Street, New York, 1932

Tahiti, 1932

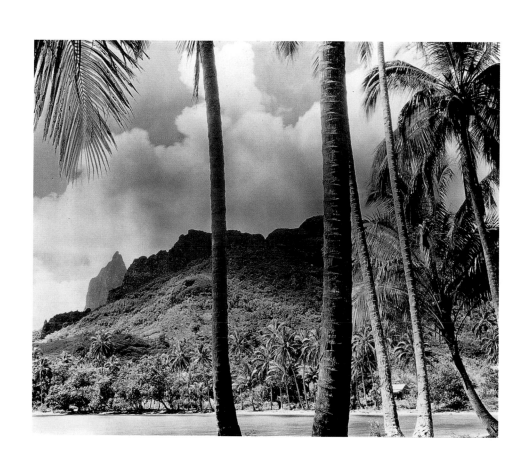

Cuban Sugar Worker, 1933

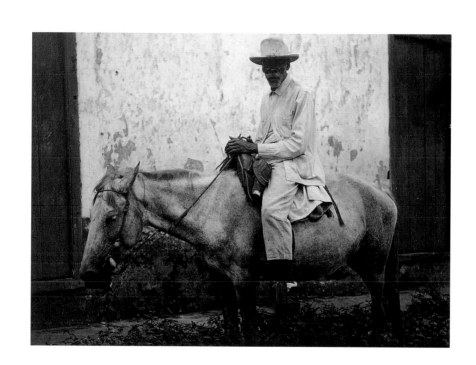

Coal Loader, Havana, 1933

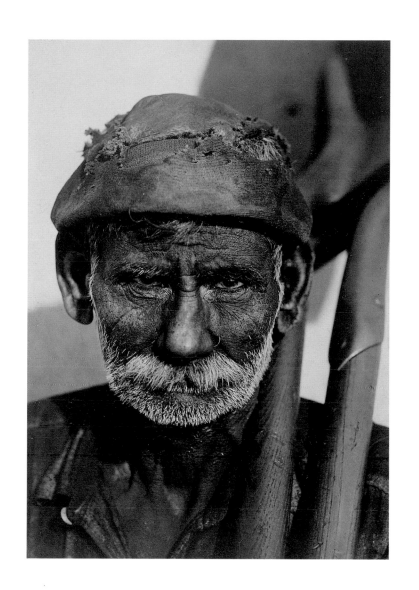

Courtyard, Havana, 1933

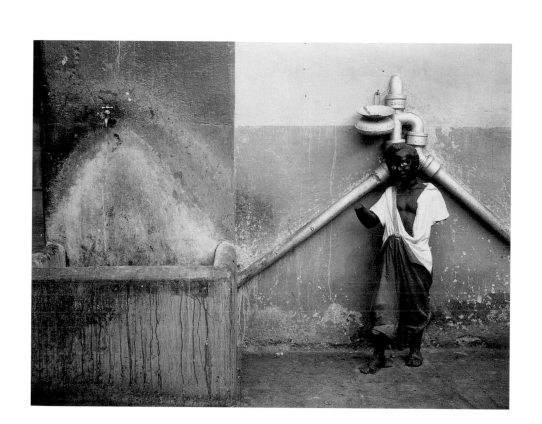

Sculptural Figure, Loango, French Congo
(Profile, Front, and Back Views), 1935

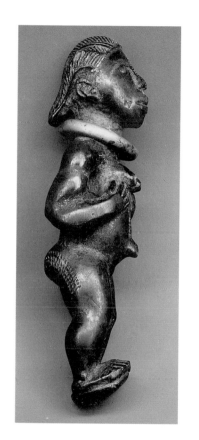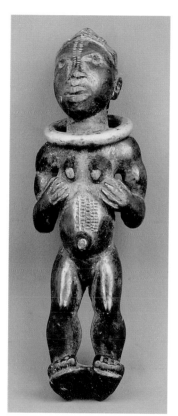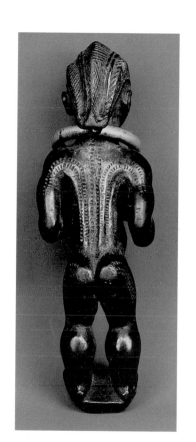

Five Fly Whisks with Carved Handles,
Baule, Ivory Coast, 1935

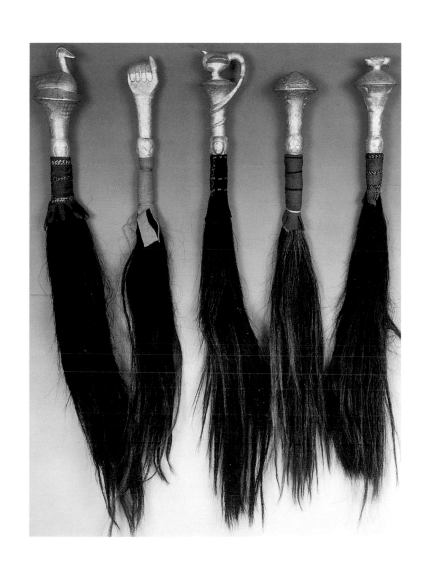

Mask, WaRegga, Belgian Congo, 1935

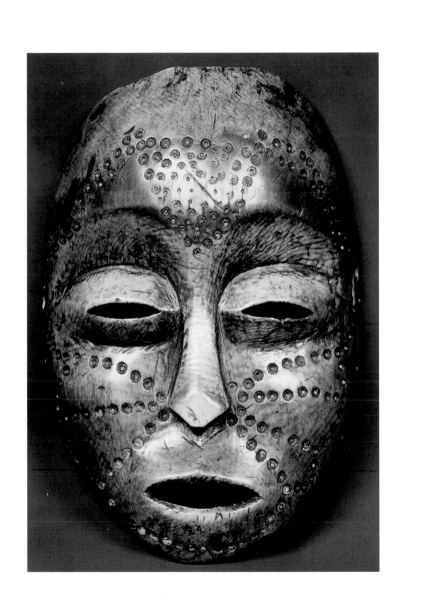

Louisiana Factory and Houses, 1935

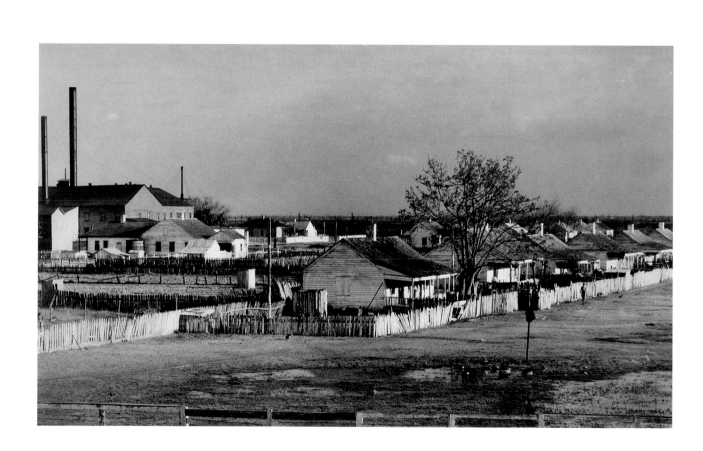

Man with Cigar, Southeastern U.S., ca. 1935

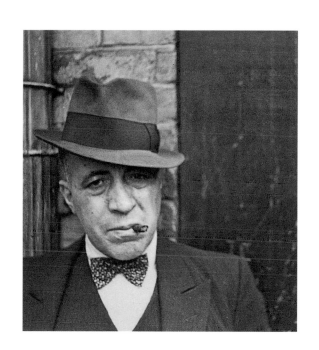

The Henry McAlpin House ("The Hermitage")

near Savannah, Georgia, 1935

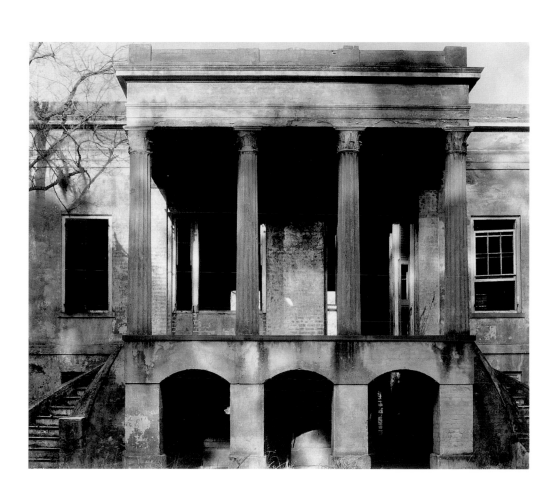

Jane Ninas, Belle Grove Plantation,
White Castle, Louisiana, 1935

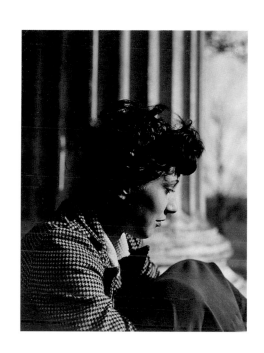

Breakfast Room, Belle Grove Plantation,
White Castle, Louisiana, 1935

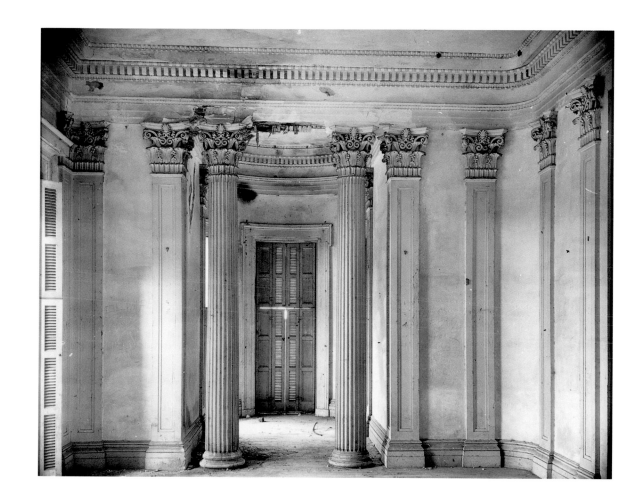

Sprott, Alabama, 1936

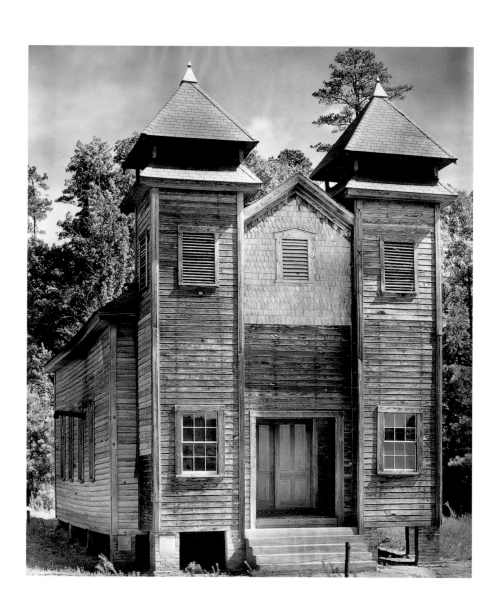

Southern Farmland, 1936

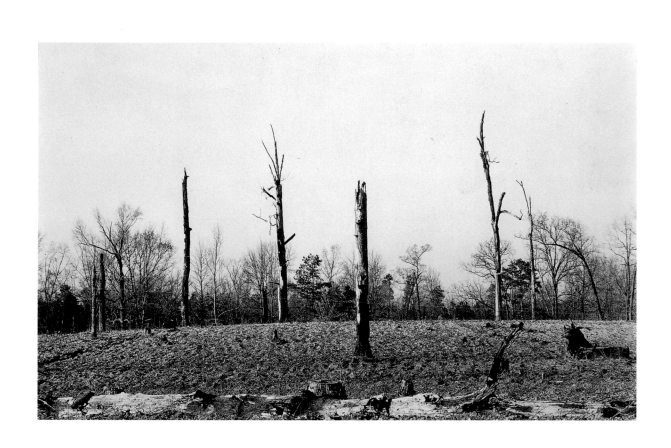

Alabama Country Fireplace, 1936

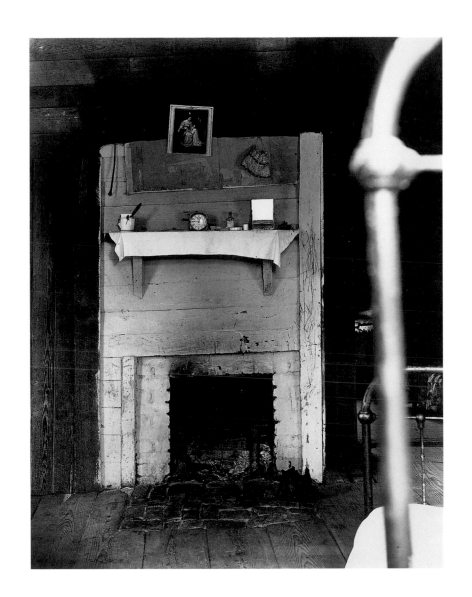

Penny Picture Display, Savannah, Georgia, 1936

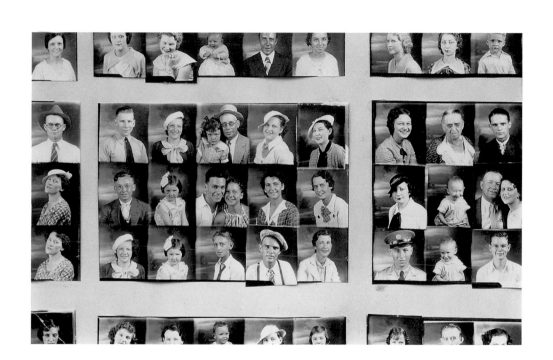

Street Scene, New Orleans, 1956

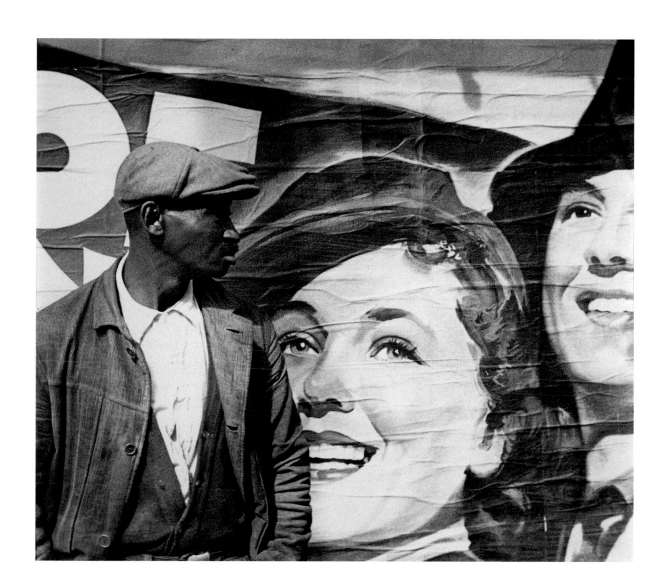

Church Organ and Pews, 1936

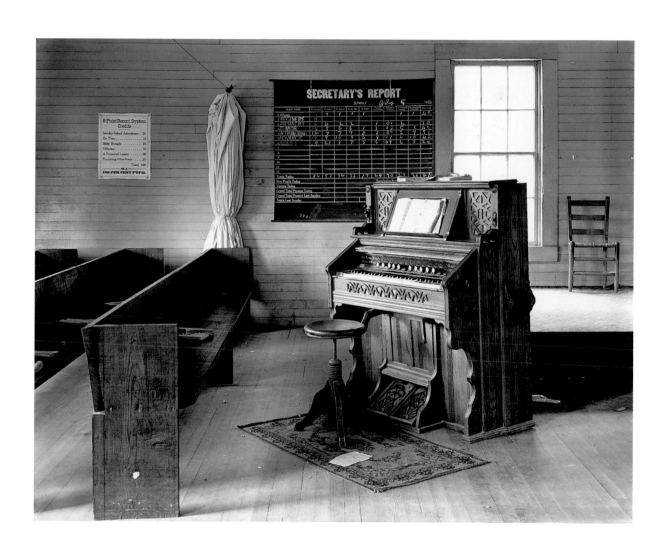

Furniture Store Sign near Birmingham,

Alabama, 1936

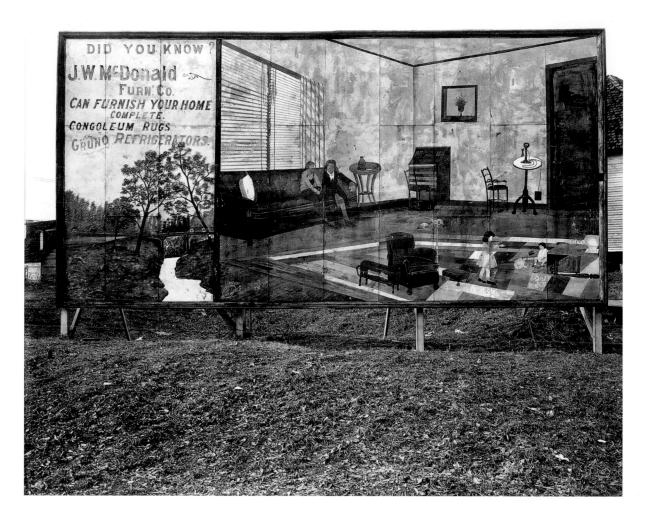

Battlefield Monument, Vicksburg, Mississippi, 1936

Minstrel Showbill, 1936

Easton, Pennsylvania, 1936

S. Klein's Department Store, New York, 1937

James Agee, Old Field Point, New York, 1937

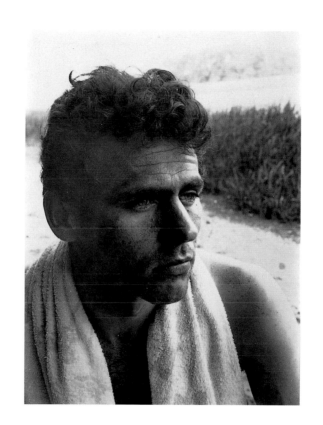

Subway Portrait, New York, 1938

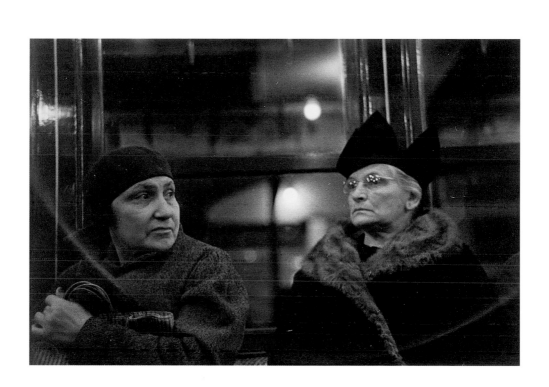

Subway Portrait, New York, 1938

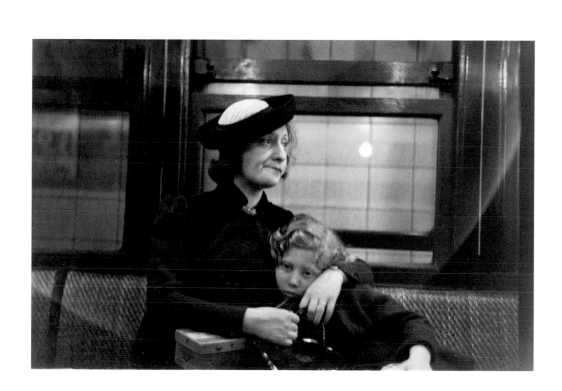

Subway Portrait, New York, 1938

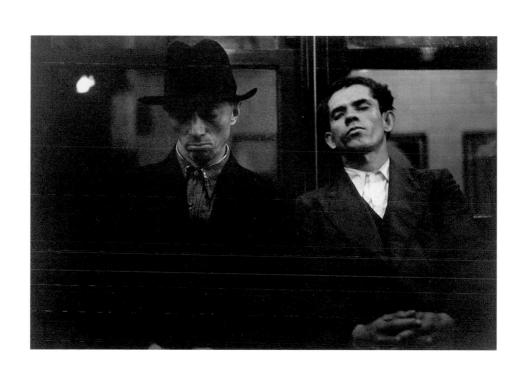

Palm Trees, The Gulf of Mexico, Florida, 1941

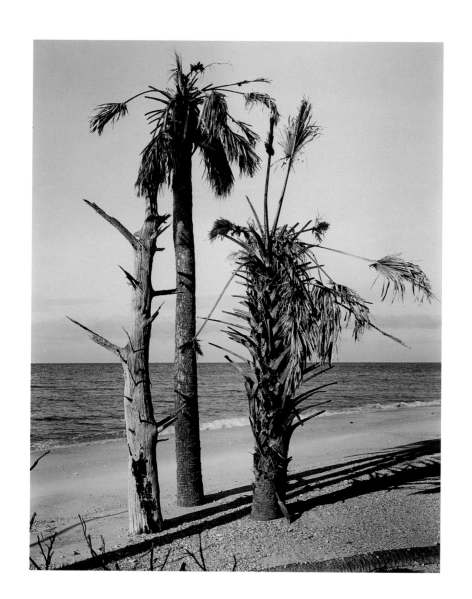

Municipal Trailer Camp, Sarasota, Florida, 1941

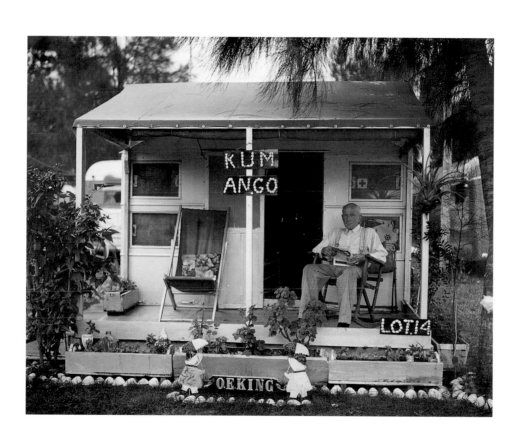

Uninhabited Residence near Sarasota, Florida, 1941

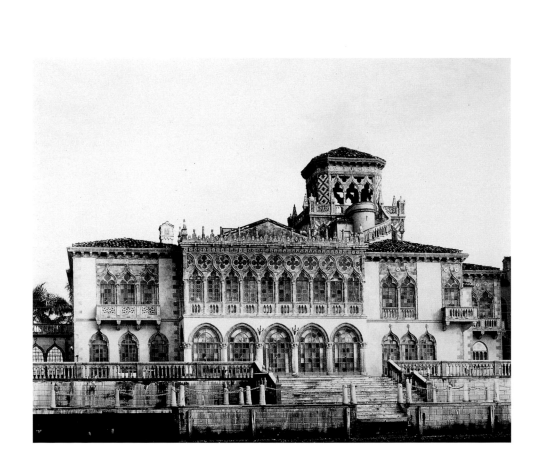

Grave, Florida, 1941

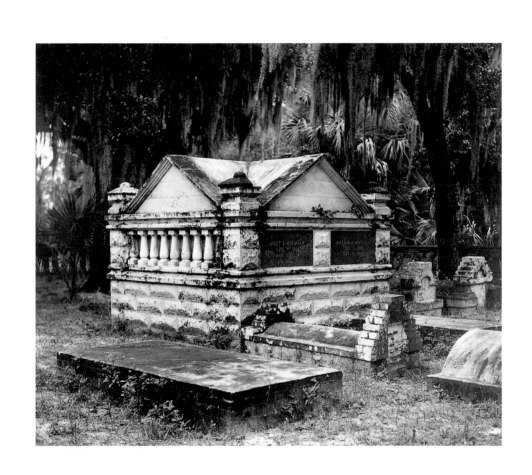

Halsted Street, Chicago, 1946

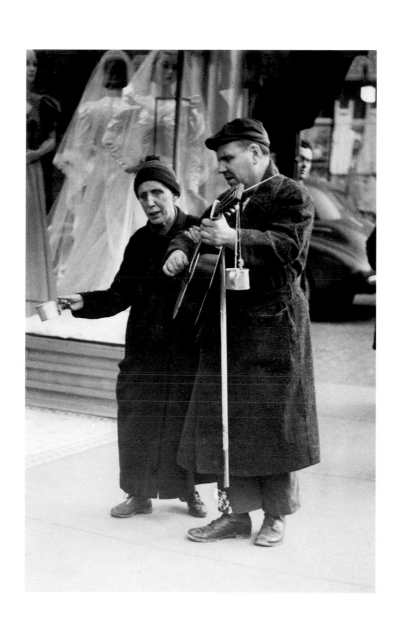

Two Junked Boilers, probably Detroit, 1946

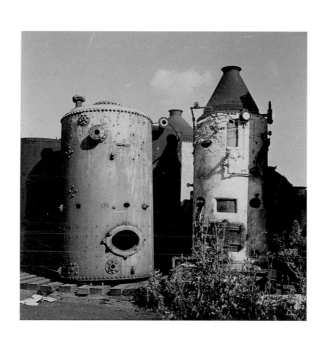

Man on the Street, Detroit, 1946

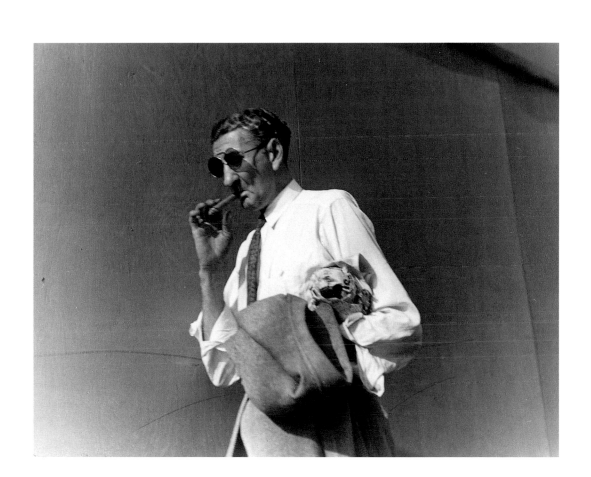

Shoppers, Randolph Street, Chicago, 1946

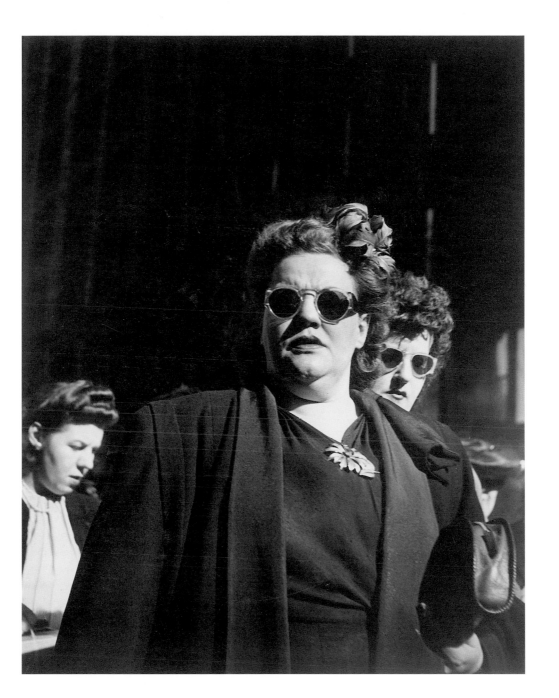

"The Superrench"–Two-Ended Wrench, 1955

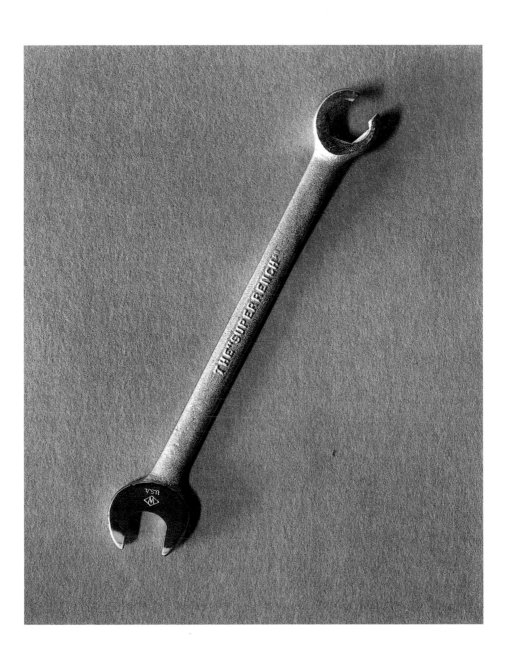

Stove, Heliker House, Cranberry Island, Maine, 1969

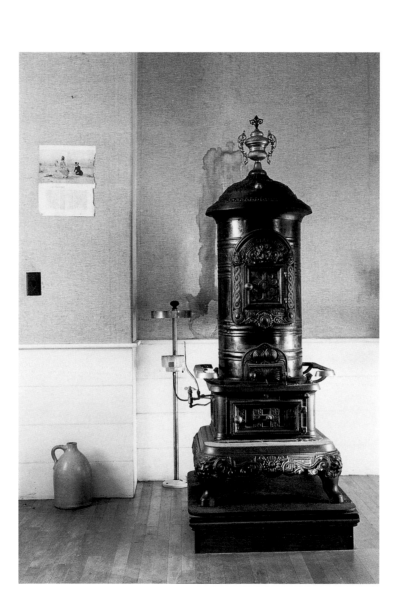

Audrey, Atlanta, 1973

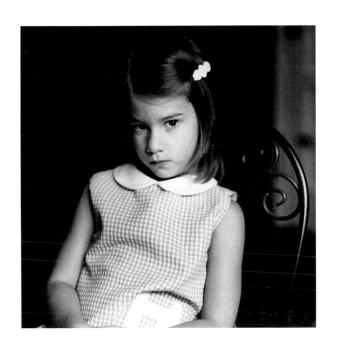

Graffiti on Red Pole, 1974

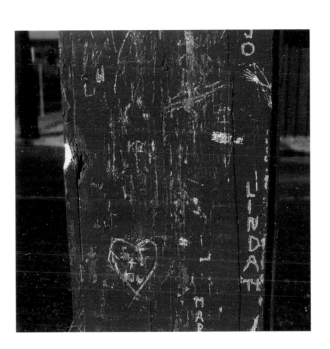

Graffiti: "Here," 1974

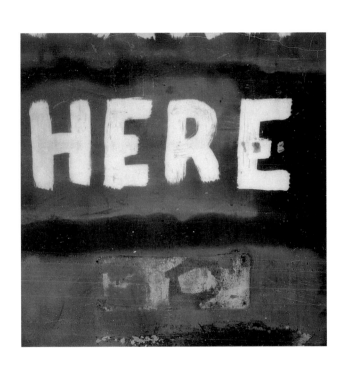

Annotated Checklist

Compiled by Benjamin A. Hill, Audrey Hill,
and Ellen Fleurov

The following catalogue entries include the title, date, dimensions, marks, and inscriptions, when applicable, related to the Walker Evans photographs in the Hill Collection, as well as references to published literature where these images or variant images appear. All unbracketed titles were assigned by Walker Evans. For works that bear no Evans title or when the title is inadequate, a descriptive title has been assigned, as ascertained through new research or from other secondary sources, and it appears in brackets. Evans sometimes misattributed or misspelled place names in his titles or inscribed the wrong dates on his prints. In these instances (checklist nos. 34, 35, 44, 45, 78, and 82), the titles and dates have been corrected. The photographs are vintage gelatin silver prints, unless otherwise noted. For prints made considerably later than the negative, both dates are provided. When dating is not available through inscriptions on the object or published literature, an approximate date has been given. In most of the entries, measurements are for the image size and are given height before width. In some cases, however, the photographs are on original mounts assembled by Evans, trimmed to the image. Therefore, sheet and/or mount sizes are provided only when they differ from that of the image.

Various inscriptions, signatures, stamps, labels, and other notations found on the objects have been transcribed and are italicized. Unless otherwise noted, all inscriptions are by an unknown hand or by a previous collector or vendor. Reference is made first to any notations on the front (recto), followed by any documentation on the back (verso). The verso of nine photographs in the Hill Collection contain abbreviated technical notes on developing and printing processes as well as instructions on image size and cropping for commercial use. While some notes are illegible, information is often deducible. For example, the annotations found on the verso of *Delancey Street* (checklist no. 8) read: *"#4 AZO"* [a contrast grade of Azo paper] *"50 W 20 S"* [50 watt, 20 seconds]. Two photographs in the Hill Collection (checklist nos. 20 and 50) bear a Museum of Modern Art loan number, which indicates that the particular print was on loan to the Museum either for the seminal 1938 exhibition *Walker Evans: American Photographs* and/or the circulating exhibition *American Photographs by Walker Evans.* Furthermore, five photographs (checklist nos. 9, 22, 26, 53, and 56) may have appeared in a maquette for the 1938 publication *American Photographs*, since a label affixed to each print verso indicates in which section of the book the image was to be included (Part I or II) and its plate number. Three photographs (checklist nos. 45, 54, and 55) were presented to the collector by the artist and also bear original presentation mats with Evans's signature.

The standard locations of marks and inscriptions are abbreviated as follows: UL (upper left); UC (upper center); UR (upper right); ML (middle left); MC (middle center); MR (middle right); LL (lower left); LC (lower center); and LR (lower right).

Six different Evans signature and address stamps appear in the Hill Collection out of a known fourteen that Evans used throughout his career. Each of the Evans studio stamps reproduced here has been assigned its own Roman numeral, and each has also been cross-referenced to the list established by Judith Keller in her catalogue raisonné of the Evans holdings in the J. Paul Getty Collection (see *Getty,* pp. xii and xvi). These studio stamps cannot always serve as a reliable guide to dating prints but, according to Keller, they can be "considered evidence of dates when the photographer was reviewing work." The Lunn Gallery stamp and reference numbers refer to the "Estate Stamp" created in 1975 by the dealer Harry H. Lunn, Jr., with Evans's approval, as a means of authenticating photographs purchased for the gallery's inventory. The two-part box below the stamp was used to identify a major category of Evans's work (on the left) and to record an inventory number for a specific print (on the right). For example, on the verso of the print *Forty-Second Street,* (checklist no. 9), the Lunn Gallery stamp reads: "I" (for AP: *American Photographs,* 1938) and "46." For a fuller explanation of Lunn's cataloguing system, the reader should consult the list compiled by Judith Keller (see *Getty,* p. xvii).

The catalogue entries also include abbreviations for the first published source of an image, when known, and more recent publications in which the work or a variant negative or significant variant cropping is cited. An asterisk (*) preceding a bibliographic citation indicates that the work from the Hill Collection has been previously published in that source. A complete listing of the articles and books most frequently cited below can be found at the end of this checklist. There are thirteen works by Walker Evans in the Hill Collection which have not previously been published, and so no citation is given.

I [A]

Walker Evans

II [B]

WALKER EVANS

III [C]

WALKER EVANS

IV [F]

WALKER EVANS
163 EAST 94th STREET
NEW YORK 28, N. Y.

V [I]

WALKER EVANS
1681 YORK AVENUE
NEW YORK, N. Y. 10028

VI [K]

WALKER EVANS
BOX 310 RTE. 3
OLD LYME. CONN. 06371

Lunn Gallery

Walker Evans

1 46

Studio stamps
in the Hill Collection
shown actual size

1

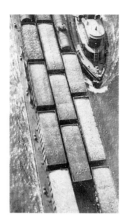

3

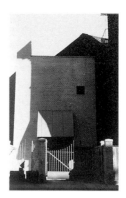

2

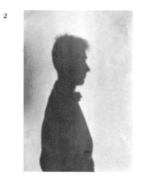

4

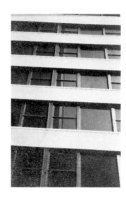

5

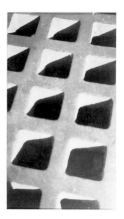

6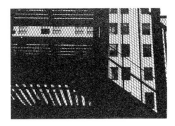

7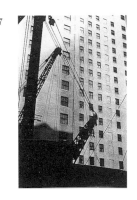

8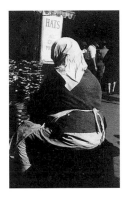

9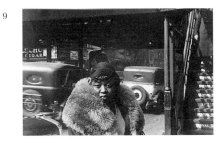

10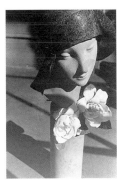

11 *[Brooklyn Bridge Composition]*, 1929
2⅜ x 4 inches (6 x 10 cm)
Documentation: (Verso) at UL,
in pencil, by Evans, *Walker Evans*
PAGE 35

12 *Brooklyn Bridge*, 1929,
Modern photogravure from the original
negative printed by Jon Goodman, from the
portfolio *The Brooklyn Bridge*
(New York: Eakins Press Foundation, 1994,
3 of an edition of 100)
9⅞ x 5⅞ inches (25 x 15 cm)
Sheet: 17 x 14 inches (43.1 x 35.5 cm)

13 *Hart Crane, Brooklyn, New York*, 1929
3⅜ x 3 inches (8.6 x 7.2 cm)
Documentation: (Verso) at UL, wet stamp in
black ink, *RIGHTS RESERVED* (sideways);
at LC, in black ink, *by*,
and below, at LC, Evans Studio Stamp III
(Getty Stamp C)
Bibliography: "Hart Crane, Brooklyn, NY,
1929," *Hound & Horn* 7 (July-September
1934), facing p. 682; *Incognito*, n.p.
PAGE 35

14 *Paul Grotz, Darien, Connecticut*, 1929
3¼ x 2¼ inches (8.3 x 7 cm)
Documentation: (Verso) at ML, in pencil,
1929 Darien, CT.

15 *Berenice Abbott*, 1930
6⅝ x 4⅝ inches (16.8 x 11.7 cm)
Documentation: (Verso) at MC,
Evans Studio Stamp III (Getty Stamp C);
and below, at MC, wet stamp in black ink,
RIGHTS RESERVED
Bibliography: *First and Last*, p. 133
PAGE 37

11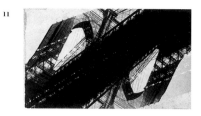

14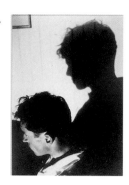

12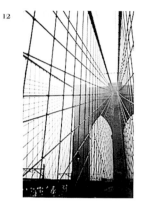

15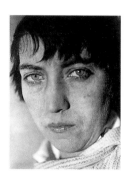

13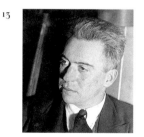

16 *[Window of a Shingled House],* ca. 1930
6⅜ x 4½ inches (16.2 x 11.4 cm)
(on original mount trimmed to image)
Documentation: (Verso, mount) at MC, Lunn
Gallery Stamp, and within boxes,
in pencil, *III* and *544;* at LL, in pencil, *#5;*
at LC, in pencil, *#5*
Bibliography: *Getty,* no. 133

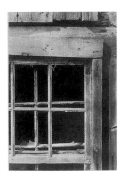

16

17 *[Wood Shingles],* 1930
6⅜ x 4½ inches (16.2 x 11.4 cm)
Documentation: (Verso) at MC,
Lunn Gallery Stamp, and within boxes,
in pencil, *III* and *543;* at LL, in pencil, *#2*
Bibliography: *Getty,* no. 135

18 *Wash Day, New York,* ca. 1930
7⅜ x 4⅞ inches (18.7 x 12.4 cm)
(on original mount trimmed to image)
Documentation: (Verso, mount) at LC,
Lunn Gallery Stamp (boxes left blank)
Bibliography: "New York City," *Hound &
Horn* 4 (October–December 1930), n.p.;
* *First and Last,* p. 2
PAGE 39

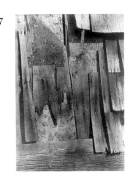

17

18

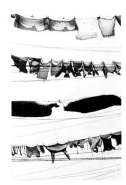

19

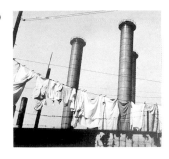

19 *[Clothes Line and Smoke Stacks, New York],*
ca. 1930
8⅛ x 9 inches (20.6 x 22.9 cm)
(dry mount tissue on verso trimmed to image)
Documentation: (Verso) at UL, in pencil, *WE*
Bibliography: *Getty,* no. 83 (variant)

20

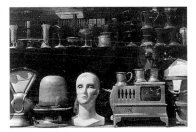

20 *[Secondhand Shop Window],* 1930
4½ x 6½ inches (11 x 16.5 cm)
(on original mount trimmed to image)
Documentation: (Verso, mount) at UC,
in pencil, *evans;* at UR, in pencil, MoMA
loan number *38.2386;* at MC, Lunn Gallery
Stamp, and within boxes, in pencil, *XIV;*
at MC, in pencil, *c. 1930*
Bibliography: *Getty,* no. 122
PAGE 41

21 *[Gingerbread House, Dedham, Massachusetts]*, ca. 1930-31
5¾ x 5⅜ inches (9.5 x 13.7 cm)
Support: 10 x 7 inches (25.4 x 17.8 cm)
Documentation: (Verso, mount) at UC, in pencil, *19th c. Gingerbread House, Dedham, Mass, 1931/used in 1933 moma show;* at MC, Evans Studio Stamp I (Getty Stamp A); at MC, Lunn Gallery Stamp, and within boxes, in pencil, *IX* and *43;* at LL, in pencil, *#4;* at LC, Lunn Gallery Stamp, and within boxes, in pencil, *IX* and *43*
Bibliography: *Getty*, no. 157

22 *View of Ossining, New York,* 1930
4¾ x 7½ inches (12.1 x 19.1 cm)
Sheet: 8 x 10 inches (20.3 x 25.4 cm)
Documentation: (Verso, sheet) at UC, in pencil, by Evans, *C3 30S W5* (inverted); at UR, in pencil on adhesive label, *II 4;* at MC, Evans Studio Stamp IV (Getty Stamp F); at LL, in pencil, *#136/Box 12;* at LC, Lunn Gallery Stamp, and within boxes, in pencil, *I* and *118;* at LR, in pencil, *WE 224* (sideways)
Bibliography: *American Photographs,* Part II, no. 4; *Getty*, no. 144
PAGE 43

23 *Circus Signboard,* ca. 1930
8⅝ x 6⅜ inches (21.9 x 16.2 cm)
Documentation: (Verso), at UL, in pencil, *15* (sideways); at LL, in pencil, *#504;* at LC, in pencil, *RMG #9005.011-0;* at LR, in pencil, *P75.5.21.15*
Bibliography: **Hungry Eye*, p. 507
PAGE 45

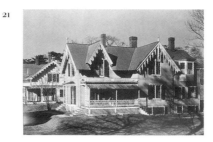

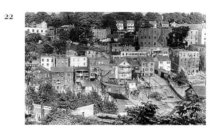

24 *Mirror, Saratoga Springs, New York,* 1951
7¾ x 6 inches (19.7 x 15.2 cm)
Documentation: (Verso) at MC, Evans Studio Stamp V (Getty Stamp I); at LL, in pencil, *#6;* at LC, Lunn Gallery stamp and within boxes, in pencil, *IX* and *3;* at LC, in pencil, *Saratoga c. 1931*
Bibliography: *Walker Evans at Work*, p. 60

25 *Main Street, Saratoga Springs, New York,* 1951, printed ca. 1970
8½ x 6½ inches (21.6 x 16.5 cm)
Documentation: (Verso) at LC, in pencil, by Evans, *Walker Evans/Saratoga 1933*
Bibliography: *American Photographs,* Part I, no. 27; *First and Last*, p. 47
PAGE 47

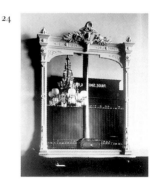

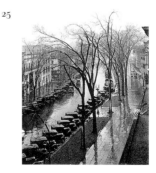

26 *Jigsaw House, Ocean City, New Jersey,* 1931
5½ x 7 inches (14 x 17.8 cm)
Documentation: (Verso) at UR, on white
adhesive label, in pencil, *II 33;* at LL,
in pencil, *#1729;* at LL, Lunn Gallery Stamp,
and within boxes, in pencil, *I* and *176;*
at LR, in pencil, *vintage*
Bibliography: *American Photographs,*
Part II, no. 33; *Getty,* no. 151
PAGE 49

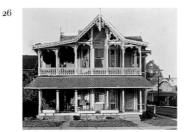

27 *Roxbury Water Tower, Massachusetts,* 1931
6¼ x 3⅜ inches (15.9 x 8.6 cm)
Mount: 11¼ x 14¼ inches (28.6 x 36.2 cm)
Documentation: (Verso, mount), at UL, in
pencil, *labeled Gothic Church, Dorchester,
1931/used in 1933 moma show;* at UR, in
pencil, *WE.136;* at MC, Lunn Gallery Stamp,
and within boxes, in pencil, *IX* and *96;*
at MC, in pencil, by Evans, *Roxbury Water
Tower;* at LR, in pencil, by Evans, *11*
Bibliography: **Hungry Eye,* p. 56
PAGE 51

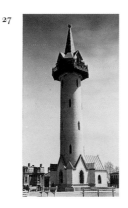

28 *Moving Truck and Bureau Mirror,* ca. 1931
4⅝ x 6⅝ inches (11.7 x 16.8 cm)
Documentation: (Verso) at LL, in pencil,
#1737; at LR, Lunn Gallery Stamp, and
within boxes, in pencil, *II* and *32;*
at LR, in pencil, *WE 0025*
Bibliography: *MoMA,* p. 32;
Hungry Eye, p. 165, no. 88
PAGE 53

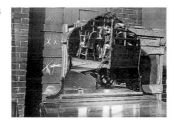

29 *Child in Backyard,* 1932
7½ x 5¾ inches (19.1 x 14.6 cm)
(on original mount trimmed to image)
Documentation: (Verso, mount) at LL,
in pencil, *#1;* at LC, Lunn Gallery Stamp,
and within boxes, in pencil, *I* and *40*
Bibliography: *American Photographs,* Part I,
no. 16; *Hungry Eye,* p. 189, no. #21
PAGE 55

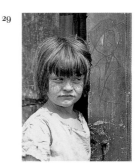

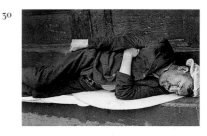

30 *South Street, New York,* 1932
5⅛ x 7¾ inches (13 x 19.7 cm)
(on original mount trimmed to image)
Documentation: (Verso, mount) at ML, in
black ink, *1 - 49;* at MC, in pencil, MoMA
loan number *38.2418* and *22 evans;* at MR,
Lunn Gallery Stamp (boxes left blank);
at LL, in pencil, *#1691*
Bibliography: *American Photographs,*
Part I, no. 49; **First and Last,* p. 9
PAGE 57

31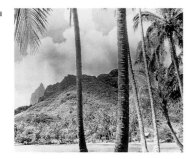

34 *Courtyard, Havana,* 1933
6 x 7⅞ inches (15.2 x 20 cm)
Mount: 18 x 15 inches (45.7 x 38.1 cm)
Documentation: (Recto, mount) at LR,
in pencil, by Evans, *Walker Evans 1932* (sic);
(Verso, mount) at MC, in pencil, by Evans,
Havana Courtyard Detail/Havana, Cuba.
1932; at MC, Evans Studio Stamp III
(Getty Stamp C) and below,
in pencil, by Evans, *Walker Evans*
Bibliography: *MoMA,* p. 59; *Havana,* p. 70
PAGE 65

32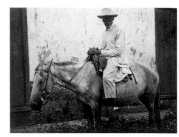

33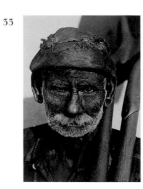

31 *[Tahiti],* 1932
6¼ x 7½ inches (16 x 19.1 cm)
Documentation: (Verso) at MC, in pencil,
XVI; at LR, Lunn Gallery Stamp,
and within boxes, in pencil, *XVI* and *13;*
at LR, in pencil, *#2*
PAGE 59

32 *Cuban Sugar Worker,* 1933
4⅞ x 6½ inches (12.4 x 16.5 cm)
(on original mount trimmed to image)
Documentation: (Verso, mount) at MC,
in pencil, by Evans, *Cuban Sugar Worker;*
at MC, in pencil, by Evans, *Walker Evans*
Bibliography: *Havana,* p. 51
PAGE 61

33 *Coal Loader, Havana,* 1933
6½ x 4⅝ inches (16.5 x 11.7 cm)
(on original mount trimmed to image)
Documentation: (Verso, mount) at UR,
on white adhesive label, in pencil, *I 33/AP;*
at MC, Evans Studio Stamp IV
(Getty Stamp F)
Bibliography: *American Photographs,*
Part I, no. 33; *Havana,* p. 77
PAGE 63

35 *[General Store, Cuba],* 1933
5⅞ x 7⅝ inches (15 x 19.5 cm)
Mount: 18 x 15 inches (45.7 x 38.1 cm)
Documentation: (Recto, mount) at LR,
in pencil, by Evans, *Walker Evans 1932* (sic)
Bibliography: *First and Last,* p. 31;
Havana, p. 102

36 *Bread Line, Havana,* 1933
6⅝ x 8⅜ inches (17 x 21.5 cm)
Documentation: (Verso) at UC,
Lunn Gallery Stamp, and within boxes,
in pencil, *XVII* and *18;* at UR,
in pencil, *MI47;* at LL, in pencil, *#1*
Bibliography: *Crime of Cuba,* pl. 18;
Havana, p. 15

34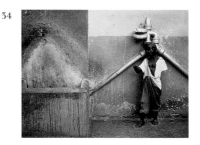

35

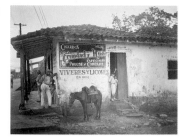

36

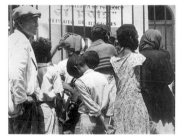

37 *[Sculptural Figure, Loango, French Congo (Profile, Front, and Back Views)]*, 1935
Each 7½ x 3¼ inches (each 19 x 8.2 cm)
Documentation: (Verso) at MC, on each print, Lunn Gallery Stamp,
and within boxes, in pencil, *XX* and *394;*
at LL, on profile view, in pencil, *#342;*
at LL, on front view, in pencil, *#341;*
at LL, on back view, in pencil, *#343*
PAGE 67

37

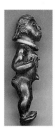 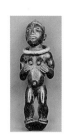 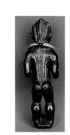

38 *[Five Fly Whisks with Carved Handles, Baule, Ivory Coast]*, 1935
9⅛ x 7⅛ inches (19.1 x 8.3 cm)
Documentation: (Verso) at MC, in pencil, *146-150;* at MR, Lunn Gallery Stamp, and within boxes, in pencil, *XX* and *146-150;*
at LL, in pencil, *139;* at LC, in pencil, *1934-35*
PAGE 69

38

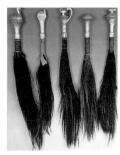

39 *[Mask, WaRegga, Belgian Congo]*, 1935
8 x 5½ inches (20.3 x 14 cm)
Documentation: (Verso) at MC, in pencil, *455;* at MC, Lunn Gallery Stamp, and within boxes, in pencil, *XX* and *455;*
at LL, in pencil, *432*
Bibliography: *African Folktales*, pl. 154;
Hungry Eye, p. 98
PAGE 71

39

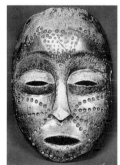

40 *[Figure, Surmounting a Calabash, Urua, Belgian Congo]*, 1935
9 x 7⅜ inches (22.9 x 18.7 cm)
Documentation: (Verso) at MC, in pencil, *489;* at MC, Lunn Gallery Stamp, and within boxes, in pencil, *XX* and *489;*
at LL, in pencil, *383*
Bibliography: *African Folktales*, pl. 97

40

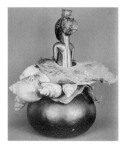

41 *Louisiana Factory and Houses,* 1935
7⅜ x 12¼ inches (18.7 x 31.1 cm)
Documentation: (Verso) at MC,
Lunn Gallery Stamp (sideways), and within
boxes, in pencil, *I* and *130* (check mark);
at LC, in pencil, *sugar plantation. 1935/
New Orleans Vicinity/enlargement from
8 x 10 neg/American Photographs,*
(underlined) *variant cropping*
Bibliography: *American Photographs,*
Part II, no. 10 (variant);
Hungry Eye, p. 196, no. 5 (variant)
PAGE 73

42 *[Man with Cigar, Southeastern U.S.],*
ca. 1935
6⅜ x 5¾ inches (16.2 x 14.6 cm)
(dry mount tissue on verso
trimmed to image)
Documentation: (Verso) at MC,
Lunn Gallery Stamp (boxes left blank);
at LL, in pencil, *21;* at LC, in pencil, *612*
PAGE 75

43 *[The Henry McAlpin House ("The Hermitage")
near Savannah, Georgia],* 1935
7½ x 8⅞ inches (19.1 x 22.5 cm)
Mount: 18 x 15 inches (45.7 x 38.1 cm)
Documentation: (Verso, mount) at MC,
Evans Studio Stamp III (Getty Stamp C)
PAGE 77

41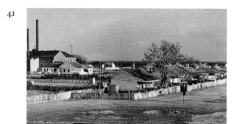

42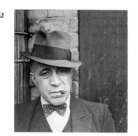

43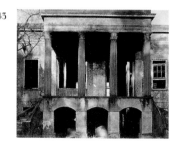

44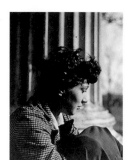

45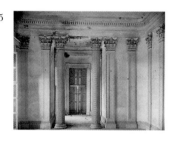

44 *[Jane Ninas, Belle Grove Plantation,
White Castle, Louisiana],* 1935
4⅜ x 3⅜ inches (11.1 x 8.1 cm)
PAGE 79

45 *Breakfast Room, Belle Grove Plantation,
White Castle, Louisiana,* 1935,
printed ca. 1970
7⅛ x 9¼ inches (18.2 x 23.5 cm)
Mount & Mat: 18 x 14¾ inches
(45.7 x 37.4 cm)
Documentation: (Recto, mat) at LR,
in pencil, by Evans, *Walker Evans;*
(Verso, mount) at UL, in pencil, *D2*
Bibliography: *MoMA,* p. 77;
First and Last, p. 125
PAGE 81

46 *[Prison Work Gang, Southeastern U.S.],*
 ca. 1935
 5½ x 6¾ inches (14 x 17.1 cm)
 Sheet: 7¾ x 9¾ (19.7 x 24.8 cm)
 (partial image from preceding
 35 mm frame visible)
 Documentation: (Verso, sheet) at LR,
 Evans Studio Stamp I (Getty Stamp A)
 Bibliography: *Getty,* no. 467 (variant)

47 *Sprott, Alabama,* 1936
 8½ x 7¼ inches (21.6 x 18.4 cm)
 Documentation: (Verso) at ML, Evans Studio
 Stamp VI (Getty Stamp K); at MC, Evans
 Studio Stamp VI (Getty Stamp K);
 at MC, wet stamp in black ink,
 RIGHTS RESERVED; at LL, Lunn Gallery
 Stamp, and within boxes, in pencil,
 III and *397;* at LR, in blue ink,
 by Evans, *SPROTT ALA/1936*
 Bibliography: *Farm Security Administration,*
 no. 397 (variant)
 PAGE 83

48 *Southern Farmland [Dead Trees in a Field,*
 Vicinity of Monticello, Georgia], 1936
 5¾ x 8¾ inches (14.6 x 22.2 cm)
 (on original mount trimmed to image)
 Documentation: (Verso, mount) at MC,
 Lunn Gallery Stamp (sideways,
 boxes left blank); at LL, in pencil, *1* (circled)
 Bibliography: *Farm Security Administration,*
 no. 172 (variant); *Hungry Eye,* p. 170, no. 73
 PAGE 85

46
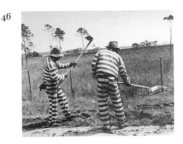

47
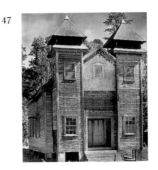

48
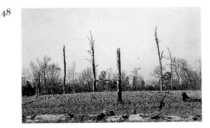

49
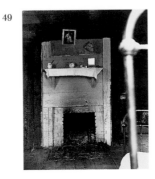

49 *Alabama Country Fireplace [Fireplace,*
 Burroughs House, Hale County, Alabama],
 1936
 9⅝ x 7⅝ inches (24.4 x 19.4 cm)
 Documentation: (Verso) at UR, in pencil,
 5 3¼ (sideways); at LL, in pencil, *WE 33303;*
 at LL, in pencil, *#3;* at LR, in pencil,
 by Evans, *variant, III-263;* at LR,
 Lunn Gallery Stamp, and within boxes,
 in pencil, *III* and *263* (check mark)
 Bibliography: *Message,* pl. 9;
 Hungry Eye, p. 205
 PAGE 87

50 *Part of Morgantown, West Virginia,* 1935
 7 x 9 inches (17.8 x 22.9 cm)
 Documentation: (Verso) at UL,
 in pencil, *WE 216;* at UR, in pencil,
 by Evans, *C2/2S* (inverted);
 at UR, Lunn Gallery Stamp,
 and within boxes, in pencil, *II* and *3;*
 at LL, in pencil, *WE1* (underlined);
 at LR, in pencil, *16* (circled)
 Bibliography: *Farm Security Administration,*
 no. 3 (variant); *Hungry Eye,* p. 195, no. 6

50
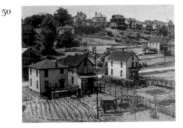

51

52

53

54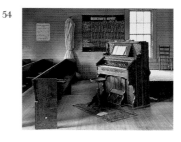

55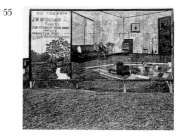

56 *Battlefield Monument, Vicksburg, Mississippi*
[Battlefield Monument to General Lloyd
Tilghman, Vicksburg National Military Park,
Vicksburg, Mississippi], 1936
7¼ x 8 inches (18.4 x 20.3 cm)
Documentation: (Verso) at UR,
on white adhesive label, in pencil, *I 29*
Bibliography: *AMP,* Part I, no. 29;
**Picturing the South,* p. 95
PAGE 97

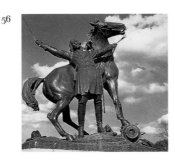

56

57 *Battlefield Monument, Vicksburg, Mississippi*
[Detail, Rhode Island Monument,
Vicksburg National Military Park,
Vicksburg, Mississippi], 1936
5⅜ x 3⅜ (13.7 x 8.6 cm)
(printed on postcard stock)
Bibliography: *Farm Security Administration,*
no. 159 (variant, full image);
Getty, no. 494 (variant, full image)

57

58 *Porch Grillwork, Mobile, Alabama,* 1936
5⅝ x 7⅜ inches (14.3 x 18.7 cm)
Documentation: (Verso) at UL, in black
grease pencil, *85* (crossed out), at UC, in red
grease pencil, *9 B* (circled)*/p.56;* at UR, wet
stamp in black ink (incomplete),
LEAVE BLA/SQUARE NO LINE; at UC,
in pencil, *2630/3-3/133;* at UR, in pencil, *86.8*
(circled); at UR to LR, in black grease pencil,
various cropping arrows and lines; at MR,
between arrows, *28½;* at LL to LR, in black
grease pencil, various cropping arrows and
lines; at MC, *34½+;* at MC, in pencil, by Evans,
Mobile Ala./Porch Grillwork detail/cast iron/
photograph by Walker Evans/1936; at MC,
Evans Studio Stamp I (Getty Stamp A); at LL,
in pencil, by Evans, *C2/5S/25W;* at LL,
in pencil, *#1188;* at LC, in pencil, *Box 25;*
at LR, Lunn Gallery Stamp, in pencil and
within boxes, *X* and *67;* at LR, in pencil, *7*
(circled, sideways)
Bibliography: *Farm Security Administration,*
no. 211 (variant)

59 *Minstrel Showbill,* 1936
6¾ x 5¾ inches (17.1 x 14.6 cm)
Mount: 10⅛ x 8¼ inches (25.7 x 21 cm)
Bibliography: *AMP,* Part I, no. 34;
Farm Security Administration,
no. 379 (variant)
PAGE 99

60 *Easton, Pennsylvania,* 1936
3⅜ x 5⅜ inches (8.6 x 13.6 cm)
(printed on postcard stock)
Documentation: (Verso) at UR,
in pencil, *WE207;* at LC, in pencil, *III45V*
Bibliography: *AMP,* Part II, no. 2
(variant, full image);
Hungry Eye, p. 331
PAGE 101

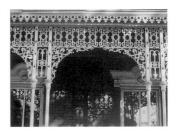

58

59

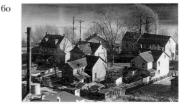

60

61 *Star Pressing Club, Vicksburg, Mississippi,*
1936
6½ x 6 inches (16.5 x 15 cm)
Documentation: (Verso) at LL, in pencil, *#3;*
at LR, Lunn Gallery Stamp, and within
boxes, in pencil, *II* and *130* (check mark)
Bibliography: *MoMA,* p. 131;
Hungry Eye, p. 326

62 *Frame Houses in Virginia,* 1936
3⅜ x 5⅜ inches (8.6 x 13.7 cm)
(printed on postcard stock)
Bibliography: *AMP,* Part II, no. 23 (variant,
full image); *Getty,* no. 569 (variant, full image)

63 *Frame Houses in Virginia,* 1936
6 x 4¾ inches (15.2 x 12.1 cm)
Mount: 13 x 19½ inches (33 x 24.1 cm)
Documentation: (Recto, mount) at LR,
in pencil, by Evans, *Walker Evans;*
(Verso, mount) UL, in pencil, by Evans,
Frame Houses in Virginia 1936; at MC,
in blue ink, by Evans, *Walker Evans/
1681 York Ave/New York, NY/10028;*
at LL, Lunn Gallery Stamp (boxes left blank)
Bibliography: *AMP,* Part II, no. 22 (variant);
Getty, no. 570 (variant)

61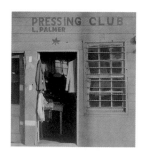

62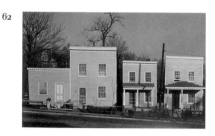

63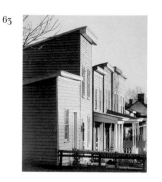

64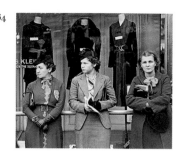

65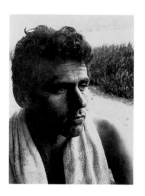

64 *[S. Klein's Department Store, New York],* 1937
5½ x 6¼ inches (14 x 15.9 cm)
Documentation: (Verso) at UL, in pencil,
M221; at LL, in pencil, *#1;* at LR, Lunn
Gallery Stamp, and within boxes, in pencil,
XIV and *18;* and below, in pencil, *c. 1929*
PAGE 103

65 *[James Agee, Old Field Point, New York],* 1937
4¾ x 3½ inches (12.1 x 9 cm)
Sheet: 6⅞ x 5⅝ inches (17.5 x 14.3)
Documentation: (Recto, sheet)
at LR, in pencil, by Evans,
Agee, August 1937/Old Field Point
PAGE 105

66 *Subway Portrait, New York,* 1938
5½ x 8¼ inches (14 x 21 cm)
Sheet: 7⅞ x 9⅞ inches (21 x 25.1 cm)
Documentation: (Recto, sheet)
at LR, in pencil, by Evans, *Walker Evans*
Bibliography: *Many Are Called,* p. 15;
Subways and Streets, p. 88
PAGE 107

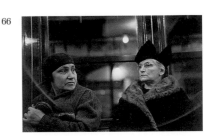
66

67 *Subway Portrait, New York,* 1938
5½ x 8¼ inches (14 x 21 cm)
Sheet: 7⅞ x 9⅞ inches (20 x 25.1 cm)
Documentation: (Verso, sheet) at LR,
Lunn Gallery Stamp, and within boxes,
in pencil, *VI* and *40;* at LR, in pencil, *58*
(circled) *Lunn Gallery, N.Y.;*
at LR, in pencil, *used in Zurich exhibition*
Bibliography: *Many Are Called,* p. 41;
Walker Evans at Work, p. 157
PAGE 109

67

68 *Subway Portrait, New York,* 1938
5 x 7½ inches (12.7 x 19.1 cm)
Sheet: 7⅞ x 9⅞ inches (20 x 25.1 cm)
Documentation: (Recto, sheet)
at LR, in pencil, by Evans, *Walker Evans*
Bibliography: *Many Are Called,* p. 123;
Subways and Streets, p. 71
PAGE 111

68

69 *Subway Portrait, New York,* 1938
2¾ x 2 inches (7 x 5 cm)
Documentation: (Verso) at MC,
Lunn Gallery Stamp (sideways),
and within boxes, in pencil, *VI* and *187*
Bibliography: *Subways and Streets,* p. 95
(variant); *Getty,* no. 796 (variant)

69

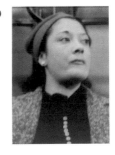

70 *[Palm Trees, The Gulf of Mexico, Florida]*,
 1941
 7½ x 5⅞ inches (19.1 x 14.9 cm)
 Mount: 11⅞ x 9¼ inches (30.2 x 23.5 cm)
 Documentation: (Recto, mount) at LR,
 in pencil, by Evans, *Walker Evans;*
 (Verso, mount) at LR, in pencil, by Evans, *11*
 Bibliography: *Mangrove Coast,* pl. 20
 (variant); **Hungry Eye,* p. 242
 PAGE 113

70
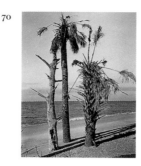

73
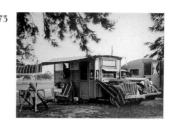

71 *Municipal Trailer Camp, Sarasota, Florida,*
 1941
 6¾ x 8¼ inches (17 x 20.5 cm)
 Documentation: (Verso) at LR,
 Evans Studio Stamp II (Getty Stamp B)
 Bibliography: *Mangrove Coast,* pl. 2;
 First and Last, 141
 PAGE 115

74
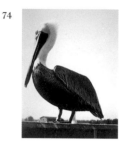

71
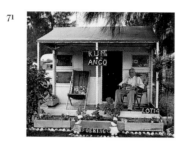

72 *Uninhabited Residence near Sarasota,*
 Florida Ca' d'Zan, The Ringling Residence,
 near Sarasota, Florida], 1941
 5¾ x 7⅛ inches (14.6 x 18.1 cm)
 Mount: 10 x 8 inches (25.4 x 20.3 cm)
 Documentation: (Recto, mount)
 at LR, in pencil, by Evans, *Walker Evans;*
 (Verso, mount) at LR, Evans Studio Stamp
 III (Getty Stamp C) (sideways)
 Bibliography: *Mangrove Coast,* pl. 10;
 Getty, no. 888
 PAGE 117

72
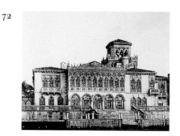

73 *[Recreational Vehicle, Florida],* 1941
 5⅝ x 7⅜ inches (14.5 x 19.5 cm)
 Mount: 11½ x 9⅜ inches (29.2 x 23.8 cm)
 Documentation: (Verso, mount) at LL,
 Evans Studio Stamp V (Getty Stamp I);
 at LR, Evans Studio Stamp I
 (Getty Stamp A);
 at LR, in pencil, by Evans, *27.*
 Bibliography: *Getty,* no. 914 (variant)

74 *Pelican, Florida,* 1941
 6¼ x 5 inches (15.9 x 13 cm)
 Mount: 11½ x 9⅜ inches (29.2 x 23.8 cm)
 Documentation: (Recto, mount) at LR,
 in pencil, by Evans, *Walker Evans;*
 (Verso, mount) at LR, in pencil, by Evans, *22.*
 Bibliography: *Mangrove Coast,* pl. 31;
 Getty, no. 928

75

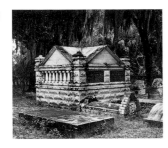

75 *Grave, Florida The Whitaker Mausoleum, Florida]*, 1941
5½ x 6½ inches (14 x 16.5 cm)
Mount: 11½ x 9¼ inches (29.2 x 23.5 cm)
Documentation: (Recto, mount) at LL, in ink, by Evans, *GRAVE*; at LC, in pencil, by Evans, *⅝;* at LR, in pencil, by Evans, *Walker Evans;* (Verso, mount) at UR, in pencil, *09329-7;* at LL, in pencil, *79* (circled); at LR, in pencil, by Evans, *Evans 16.*
Bibliography: *Mangrove Coast*, pl. 7; *Getty*, no. 909
PAGE 119

76 *[Memorial Day Parade, Bridgeport, Connecticut]*, 1941
3⅞ x 3½ inches (9.8 x 9 cm)
Mount: 15 x 13½ inches (38.1 x 34.3 cm)
Documentation: (Verso, mount) at UL, in pencil, *M140;* at UR, in pencil, *WE196;* at MC, Lunn Gallery Stamp (boxes left blank); at MC, Lunn Gallery Stamp, and within boxes, in pencil, *VIII* and *6;* at LL, in pencil, *#1;* at LR, in pencil, *In Bridgeport's War Factories/ Fortune, September 1941*
Bibliography: **Hungry Eye*, p. 253

77 *[Memorial Day Parade, Bridgeport, Connecticut]*, 1941
7¾ x 4½ inches (19.7 x 11.5 cm)
Documentation: (Verso) at UC, Lunn Gallery Stamp, and within boxes, in pencil, *VIII* and *77A* (sideways); at LL, in pencil, *3* (circled); at LR, in pencil, *In Bridgeport's War Factories/Fortune, September 1941*

78 *Halsted Street, Chicago,* 1946
7⅝ x 5¼ inches (19.5 x 13.3 cm)
Documentation: (Verso) at UR, in pencil, *WE 156;* at MC, wet stamp in black ink, *NOV 2 1941;* at LL, in pencil, *1831;* at LR, Lunn Gallery Stamp, and within boxes, in pencil, *II* and *158* (check mark); at LR, in pencil, *MOMA*
Bibliography: *MoMA,* p. 159 (variant); *Getty,* no. 1014 (variant)
PAGE 121

76

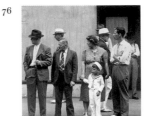

77

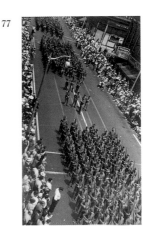

78

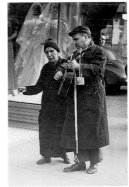

79 *[Two Junked Boilers, probably Detroit]*, 1946
2⅛ x 2⅛ inches (5.5 x 5.5 cm)
Documentation: (Verso) at MC, in pencil, *E*
Bibliography: *Getty*, no. 1023
PAGE 123

80 *[Man on the Street, Detroit]*, 1946
6 x 7¾ inches (15.2 x 19.7 cm)
Sheet: 6⅞ x 10⅞ inches (17.5 x 27.6 cm)
Documentation: (Verso, sheet, all notes
sideways) at UC, in pencil, *Labor
Anonymous/Fortune, November 1946;*
at ML, in pencil, *Fortune;* at MC,
Lunn Gallery Stamp, and within boxes,
in pencil, *V* and *608;* at LL, in pencil, *#2*
Bibliography: "Labor Anonymous,"
Fortune, November 1946, p. 153;
Hungry Eye, p. 266
PAGE 125

81 *[Man on the Street, Detroit]*, 1946
5¾ x 6½ inches (14.6 x 16.5 cm)
Bibliography: "Labor Anonymous," *Fortune,*
November 1946, p. 152; *Hungry Eye,* p. 264

82 *Shoppers, Randolph Street, Chicago,* 1946
15½ x 12¼ inches (39.4 x 31.1 cm)
Documentation: (Verso) at MC, Evans Studio
Stamp II (Getty Stamp B); at MC, wet stamp
in black ink, *RIGHTS RESERVED;* at MC,
Evans Studio Stamp VI (Getty Stamp K);
at LL, Lunn Gallery Stamp, and within
boxes, in pencil, *II* and *162;* at LL, in pencil,
#250; at LC, in pencil, by Evans, *Shoppers,
Randolph Street, Chicago 1947* (sic);
at LR, in pencil, by Evans, *Walker Evans*
Bibliography: *MoMA*, p. 162 (variant);
Evans at Work, p. 189 (variant)
PAGE 127

79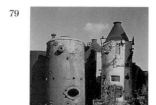

80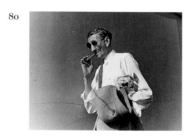

81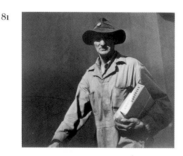

82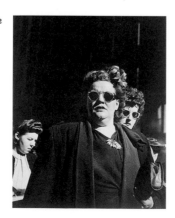

83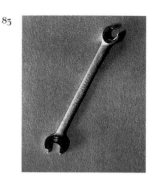

83 *"The Superrench"–Two-Ended Wrench,* 1955
9½ x 7½ inches (24.1 x 19.1 cm)
Documentation: (Verso) at LC,
Evans Studio Stamp I (Getty Stamp A);
at LR, in pencil, *withdrawn Arnold Crane*
Bibliography: **Hungry Eye,* p. 299
PAGE 129

84 *Parlor Chairs, Oldwick, New Jersey,* ca. 1958
5¾ x 4½ inches (14.6 x 11.5 cm)
Docmentation: (Verso) at LL, Lunn Gallery
Stamp, and within boxes, in pencil, *II*
and *170;* at LL, in pencil, *11* (circled);
at LL, in pencil, *WE 33302;*
at LR, in pencil, by Evans, *Walker Evans*
Bibliography: *Message,* pl. 8; *MoMA,* p. 170

85 *Stove, Heliker House, Cranberry Island,*
Maine, 1969
12¾ x 8¾ inches (32.4 x 22.2 cm)
Documentation: (Verso) at LL,
in pencil, *55* (circled)/*VCA 84*
Cast Iron Stove; at LC, in pencil, *II-176;*
at LR, in pencil, by Evans, *Walker Evans*
Bibliography: *MoMA,* p. 176
PAGE 131

86 *[Audrey, Atlanta],* 1973
8½ x 8½ inches (22 x 22 cm)
PAGE 133

87 *[Graffiti on Red Pole],* 1974
Polaroid SX-70 print
3⅛ x 3⅛ inches (7.9 x 7.9 cm)
Sheet: 4¼ x 3½ inches (10.8 x 8.9 cm)
Documentation: (Verso, sheet) at LL, in
pencil, *PF 14127;* at LC, imprinted, *10337403112*
POLAROID®; at LR, in pencil, *G292.443*
Bibliography: *Getty,* no. 1191 (variant)
PAGE 135

88 *[Graffiti: "Here"],* 1974
Polaroid SX-70 print
3⅛ x 3⅛ inches (7.9 x 7.9 cm)
Sheet: 4¼ x 3½ inches (10.8 x 8.9 cm)
Documentation: (Recto, sheet) at LR,
in ink, by Evans, *Walker Evans/*
Nov. 30, 1974/New Haven; (Verso, sheet)
at LL, in pencil, *OF 14126;* at LC, imprinted,
087401841 POLAROID®; at LR, *G6292.420*
PAGE 137

84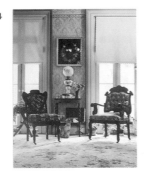

87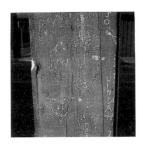

85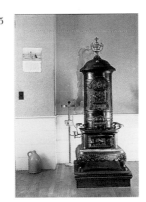

88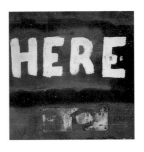

86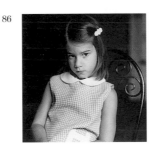

Bibliography

Beals, Carlton. *The Crime of Cuba.*
Philadelphia: J. B. Lippincott, 1933.

Bickel, Karl A., and Walker Evans.
*The Mangrove Coast. The Story of the
West Coast of Florida.*
New York: Coward-McCann, 1942.

Chevrier, Jean-Francois, Allan Sekula, and
Benjamin H. D. Buchloh.
Walker Evans and Dan Graham.
New York: The Whitney Museum of
American Art, 1992.

Crane, Hart. *The Bridge.*
Paris: Black Sun Press, 1930.

Dugan, Ellen, ed. *Picturing The South:
1860 to the Present.*
Atlanta: High Museum of Art, 1996.

Evans, Walker. *American Photographs.*
Essay by Lincoln Kirstein.
New York: Museum of Modern Art, 1938.

____. *Many Are Called.*
Introduction by James Agee.
Boston: Houghton Mifflin, 1966.

____. *Message from the Interior.*
Afterword by John Szarkowski.
New York: Eakins Press, 1966.

____. *Walker Evans.*
Introduction by John Szarkowski.
New York: Museum of Modern Art, 1971.

Greenough, Sarah. *Walker Evans:
Subways and Streets.*
Washington, D.C. :
National Gallery of Art, 1991.

Katz, Leslie, ed. *Walker Evans Incognito.*
New York: Eakins Press Foundation, 1995.

Keller, Judith. *Walker Evans:
The Getty Museum Collection.*
Malibu, California:
J. Paul Getty Museum, 1995.

Mora, Gilles. *Walker Evans: Havana 1933.*
Image sequence by John T. Hill.
New York: Pantheon Books, 1989.

Mora, Gilles, and John T. Hill.
Walker Evans: The Hungry Eye.
New York: Harry N. Abrams, 1993.

Radin, Paul, and James Johnson Sweeney.
African Folktales and Sculpture.
New York: Pantheon Books, 1953.

Sobieszek, Robert A., and Debra Irmas.
*The Camera I: Photographic Self-Portraits
from The Audrey and Sydney Irmas
Collection.*
Los Angeles: Los Angeles
County Museum of Art, 1994.

*Walker Evans: Photographs for the Farm Security
Administration, 1935-1938. A Catalogue of
Photographic Prints Available from the
Farm Security Administration Collection
in the Library of Congress.*
Introduction by Jerold C. Maddox.
New York: Da Capo Press, 1973.

Walker Evans: First and Last.
New York: Harper and Row, 1978.

*Walker Evans at Work:
745 Photographs Together with Documents
Selected from Letters, Memoranda,
Interviews, Notes.*
Essay by Jerry L. Thompson.
New York: Harper and Row, 1982.

This book is set in Walbaum Roman and
Italic, one of several typefaces bearing the
name of the German designer
and founder J. E. Walbaum (1768–1839).
The original matrices are preserved by the
Berthold Foundry.

Walker Evans was concerned with the
minute production details of books present-
ing his work, including the selection of
typefaces. A similar cutting of Walbaum
was used in the second edition of *American
Photographs.* The size and general charac-
ter of this book pay respect to Evans's earli-
est publications.

Typographic composition is by Teresa Fox,
FoxPrint, Winsted, CT.

The paper is 140GSM matte Hi Q.

Printing and binding are through
Palace Press International in China.

Designed by John T. and Dorothy O. Hill.